Dorchester

POSTCARD HISTORY SERIES

Dorchester

Earl Taylor

ARCADIA
PUBLISHING

Published by Arcadia Publishing
Charleston, South Carolina

Printed in the United States of America

Library of Congress Catalog Card Number: 2004113318

For all general information contact Arcadia Publishing at:
Telephone 843-853-2070
Fax 843-853-0044
E-mail sales@arcadiapublishing.com
For customer service and orders:
Toll-Free 1-888-313-2665

Visit us on the Internet at www.arcadiapublishing.com

CONTENTS

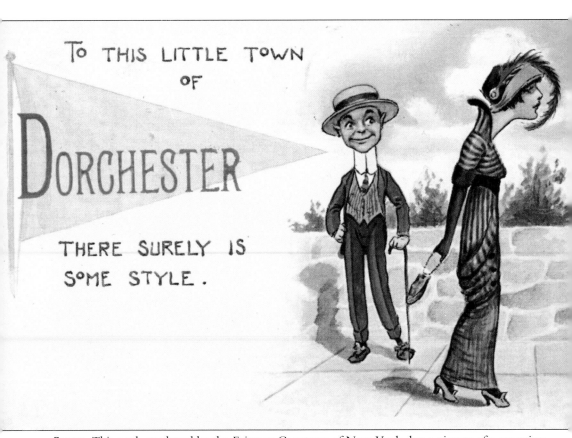

STYLE. This card, produced by the Fairman Company of New York, has a picture of a carnation on the verso, along with the phrase, "The carnation of pink perfection."

INTRODUCTION

In place of the traditional introduction, the following place names are provided to help readers locate some of the sites pictured in this book.

ADAMS CORNER, ADAMS SQUARE, AND ADAMS VILLAGE refer to the junction of Adams Street, Gallivan Boulevard, Granite Avenue, and Minot Street.

ALLEN'S PLAIN was the original name for both sides of Pleasant Street.

ASHMONT can mean the area both to the west and east of Dorchester Avenue near Ashmont Street, including Ashmont Hill and Carruth's Hill and **ASHMONT HILL**, the hill bounded by Washington Street, Talbot Avenue, and Ashmont Street.

BOWDOIN FOUR CORNERS refers to the junction of Bowdoin and Washington Streets and Harvard Avenue.

CARRUTH'S HILL is the hill bounded by Ashmont Street, Dorchester Avenue, Adams Street, and Gallivan Boulevard.

CEDAR GROVE refers to Gin Plain, the area abutting the Cedar Grove Cemetery on the north and east.

CLAM POINT is the area between Field's Corner and Morrissey Boulevard. Its southern edge is Victory Road. This area used to be included in the Harrison Square area.

CODMAN HILL is the hill bounded by Washington Street, Gallivan Boulevard, and Armandine Street.

CODMAN SQUARE refers to Baker's Corner, the intersection of Washington Street, Talbot Avenue, and Norfolk Street. By 1803 this intersection had taken its name from Dr. James Baker's store. In 1848 the intersection was officially renamed Codman Square in honor of the Rev. John Codman.

COLUMBIA POINT or Calf Pasture refers to Mile Road Dump, or the pumping station, and **COLUMBIA CIRCLE** refers to the circle on Columbia Road at the entrance to Columbia Point.

COMMERCIAL POINT, CAPTAIN'S POINT, AND PRESTON'S POINT refer to the point of land where the gas tank is located.

CRACKER HOLLOW is the intersection of Bowdoin Street and Geneva Avenue.

DOWNER SQUARE is the junction of Pleasant, Hancock, and High Streets and Downer Avenue. Originally, Downer Square included the Kane Square area.

EATON SQUARE is the intersection of Bowdoin and Quincy Streets, where St. Peter's Church is located.

EDWARD EVERETT SQUARE is the intersection of Columbia Road, Massachusetts Avenue, and Boston Street, where Richardson Park is located.

FIELD'S CORNER is the intersection of Dorchester Avenue and Adams Street.

Fox Point refers to the point of land at the eastern end of Savin Hill.

Franklin Field is the playground at the intersection of Blue Hill Avenue and Talbot Avenue.

Franklin Hill is located on the west side of Blue Hill Avenue at the junction of Talbot Avenue, opposite Franklin Field.

Franklin Park, a city park designed by Frederick Olmsted, is technically not in Dorchester, but it has become a part of Dorchester life since its creation.

Glover's Corner is the intersection of Dorchester Avenue and Freeport Street.

Grove Hall is the intersection of Blue Hill Avenue and Warren Street.

Harrison Square is an Old Colony Railroad station built in 1840, located east of Field's Corner, but not as far east as Commercial Point.

Jones Hill is the hill bounded by Hancock and Pleasant Streets, Columbia Road, and Stoughton Street.

Kane Square is the intersection of Hancock and Bowdoin Streets, by the city yard.

King Square refers to the junction of Adams Street and Neponset Avenue.

Lower Mills or Pierce Square is the intersection of Washington Street, Dorchester Avenue, and Adams Street, at the Neponset River.

Mattapan Square is the intersection of Blue Hill Avenue and River Street.

Meeting House Hill refers to the location of the current First Church, at the intersection of Adams and Church Streets, and at the intersection of Adams and East Streets.

Melville Park is the neighborhood east of Washington Street and west of Dorchester Avenue, including Melville Avenue and Park Street, and the streets in between.

Mother's Rest is a park on the east side of Washington Street, just south of Bowdoin Four Corners.

Mount Bowdoin is the hill bounded by Bowdoin and Washington Streets and Geneva Avenue.

Mount Ida and Ronan Park refer to the park on the hill sloping southwest from Meeting House Hill.

Neponset is the southeastern part of Dorchester near Neponset Circle. At one time it included Port Norfolk.

Patten's Cove is located at Savin Hill where the offices of the *Boston Globe* are now. The original Savin Hill Yacht Club was moved from Patten's Cove across Morrissey Boulevard to its current location.

Peabody Square is the intersection of Ashmont Street and Dorchester Avenue.

Pope's Hill is the hill bounded by Ashmont and Adams Streets and Neponset Avenue.

Port Norfolk is located between the mouth of the Neponset River and Tenean Beach. Seymour's Ice Cream plant was there, and Venezia Restaurant continues to operate there.

The Prairie was the name for the flat land located between Massachusetts Avenue and Norfolk Street.

Savin Hill, Rock Hill, Old Hill, and Captain's Neck refer the hill on a promontory of land at the eastern end of Savin Hill Avenue, ending in Fox Point.

Tenean Beach is the beach in the Neponset section of Dorchester that faces Port Norfolk.

Town Field is the playground at Field's Corner.

Upham's Corner is the intersection of Blue Hill Avenue and Dudley and Stoughton Streets.

Wellington Hill is the hill in Mattapan that is bounded by Blue Hill Avenue and Morton and Almont Streets.

One

PORT NORFOLK, NEPONSET, AND ADAMS VILLAGE

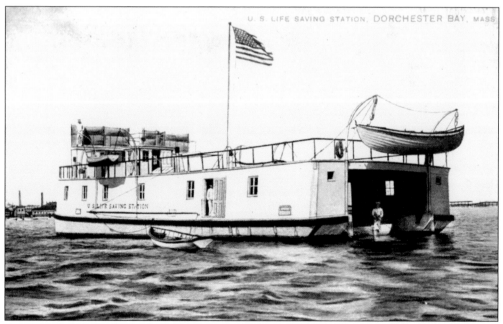

U.S. LIFESAVING STATION. Showing the U.S. Lifesaving station in Dorchester Bay, this card was printed in Germany for Mason Brothers and Company in Boston, Massachusetts.

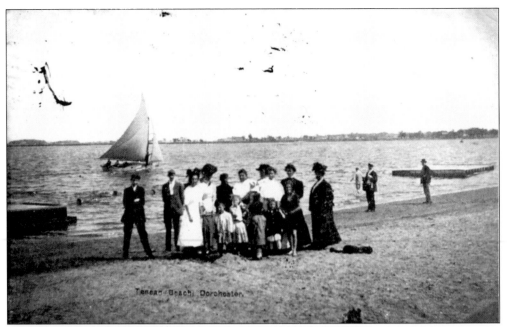

TENEAN BEACH. Entitled Tenean Beach, Dorchester, this card depicts a family outing on the shore, with a view of Dorchester Bay. Postmarked August 29, 1910, at Dorchester Station, this card was published by Putnam Art Company in Dorchester, Massachusetts.

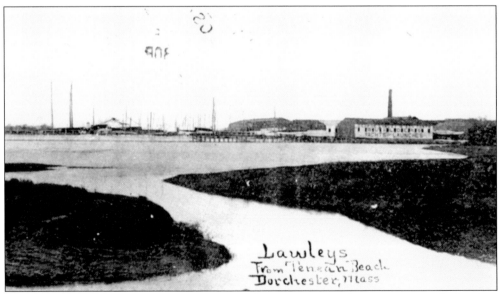

LAWLEY SHIPYARDS. The view in the picture is from Tenean Beach across Pine Neck Creek to the Lawley Shipyards. George Lawley and Sons manufactured pleasure yachts here from 1910 to 1945. Postmarked in Boston, Massachusetts, on November 5, 1918, this card was issued as the Royal Blue Card and published by Putnam Art Company in Grove Hall.

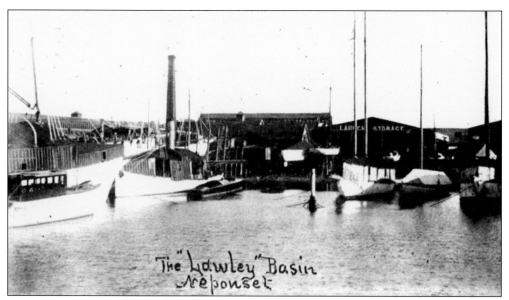

LAWLEY SHIPYARDS ON PORT NORFOLK. This card, postmarked in 1914, shows a view of the Lawley's Shipyards area on Port Norfolk. The *Guinevere* was built at the Neponset yard. It was the first yacht ever fitted with diesel oil engines to motor the electric Westinghouse equipment, which propelled the boat; hoisted the sails; lit, heated, and "cooked" the craft; and twirled the big gyroscope that kept the boat on even keel.

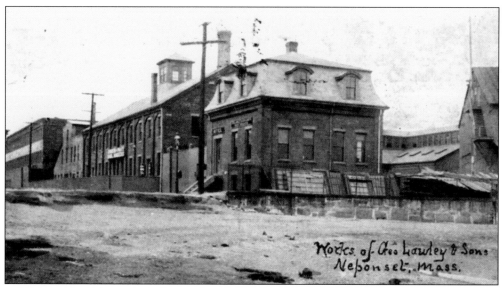

THE BUILDINGS AT LAWLEY SHIPYARDS. This card shows the buildings used by the Lawley Shipyards on Port Norfolk. In 1910 the ship manufacturing plant was moved from South Boston across Dorchester Bay to the old Putnam Nail Works at Port Norfolk. Postmarked August 17, 1915, this card was published by Putnam Art Company in Grove Hall.

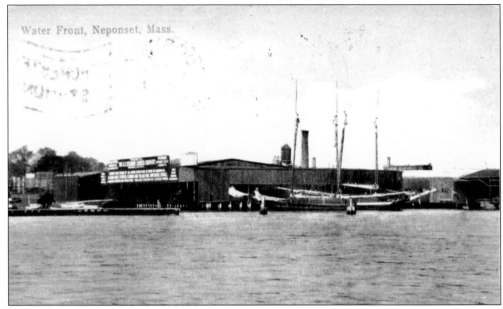

PORT NORFOLK WATERFRONT. Manufactured goods, lumber, coal, and other commodities, and people came to Dorchester by boat prior to the widespread use of the automobile and the creation of modern highways. Port Norfolk was a busy commercial port serving Pope Lumber and the Putnam nail factory. In 1910 the waterfront became the home of the George Lawley and Son Shipyards. Postmarked at Dorchester Station, this card was published by W. N. Baker, but it was printed in Germany.

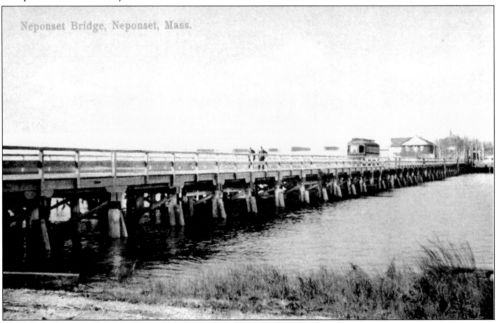

Neponset Bridge, Neponset, Mass.

NEPONSET BRIDGE. Trolley cars, automobiles, and pedestrians crossed from Neponset Circle to Quincy via this ground-level bridge. Today, a concrete arched span allows boats to pass underneath. Postmarked July 26, 1910, at Dorchester Station, this card was published by W. N. Baker and was printed in Germany.

12

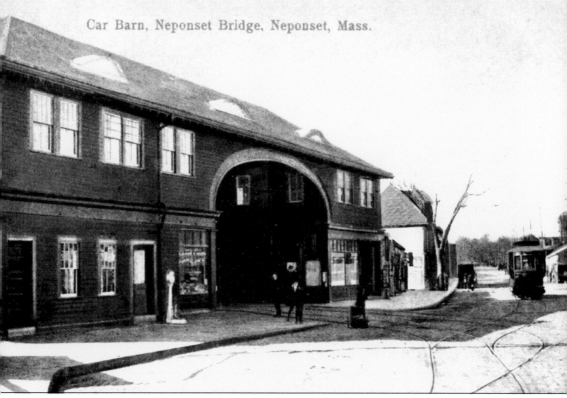

Car Barn, Neponset Bridge, Neponset, Mass.

NEPONSET CAR BARN. The car barn, which housed cars at night, was owned by the West End Street Railway Company and later by the Boston Elevated Railway Company. Trolley cars made the turnaround at Neponset Circle or continued on toward Quincy. The card was published by W. N. Baker and was printed in Germany.

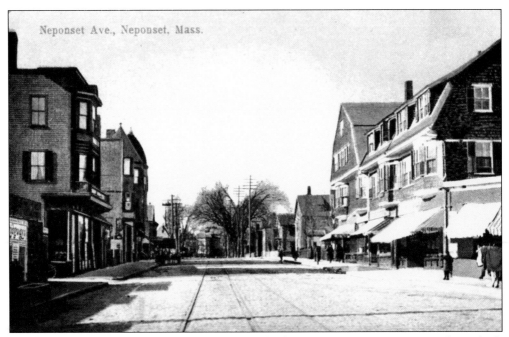

NEPONSET AVENUE. The trolley tracks ran north along Neponset Avenue, past the Baker's Pharmacy building on the right. Published by W. N. Baker and printed in Germany, this card was postmarked in 1916.

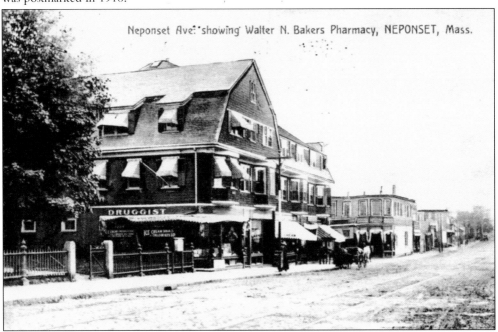

BAKER'S PHARMACY, NEPONSET. Baker's Pharmacy is located on Neponset Avenue across from Minot Street. In this picture, the avenue leads to the Neponset River Bridge, alongside the buildings in the distance, which were demolished for the construction of the Southeast Expressway. Printed in Germany and published by A. Kagan of Boston, this card was postmarked in Dorchester Center.

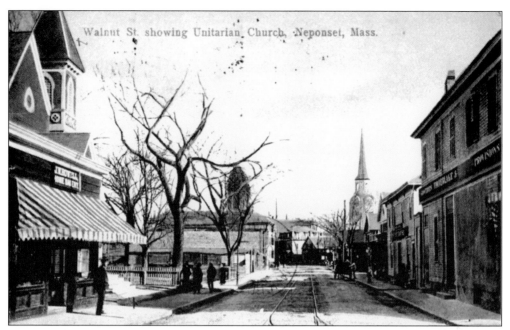

WALNUT STREET. The Neponset Fire Station appears in the distance on the left and the Unitarian church is on the right. Another church that is almost hidden in the left foreground was the Appleton Methodist Church. Printed in Germany and published by W. N. Baker, this card was postmarked February 3, 1909, at Dorchester Station.

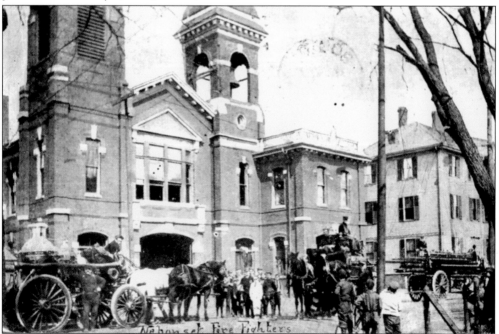

NEPONSET FIRE STATION. Horse-drawn fire engines appear in front of the Neponset Fire Station. Until it was demolished in the 1970s, this station stood on Walnut Street, which leads to Port Norfolk. Postmarked April 9, 1910, this card has a handwritten caption that reads, "Neponset Fire Fighters."

15

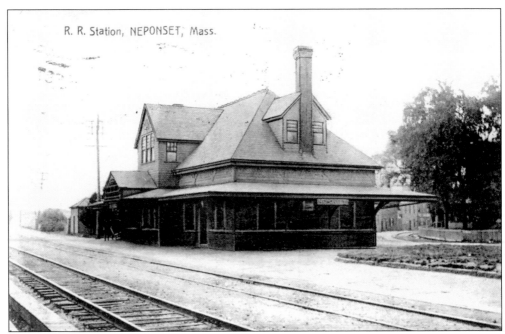

R. R. Station, NEPONSET, Mass.

NEPONSET RAILROAD STATION. In 1842 there was strong opposition to railroads, then a modern invention. When a petition was brought before the legislature asking permission to build a railroad from Boston to Quincy through Dorchester, the townspeople were bitter in their opposition, but the Old Colony Railroad prevailed. Printed in Germany and published by A. Kagan of Boston, this card was postmarked April 7, 1910.

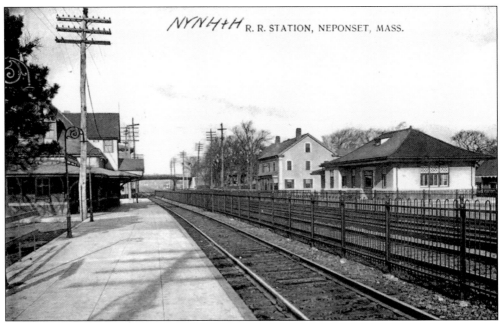

NYNH+H R. R. STATION, NEPONSET, MASS.

SOUTH SIDE OF NEPONSET RAILROAD STATION. This card, which shows a view from the south side of the station looking north, was published by Walter N. Baker, druggist of Neponset, and was postmarked January 6, 1919.

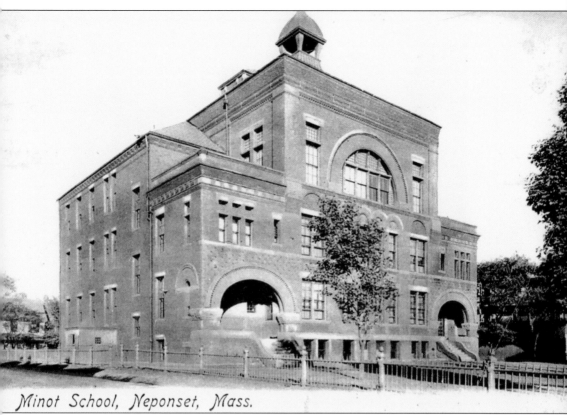

Minot School, Neponset, Mass.

MINOT SCHOOL. In 1886 a new schoolhouse was built on Neponset Avenue for the Minot School, which had formerly occupied a building on Walnut Street. The name was chosen to perpetuate the memory of the Minot family. This newer school, which had separate entrances for boys and girls, was located on Neponset Avenue where the Neponset Health Center is now, across from the entrance to Minot Street. This card was published by the Metropolitan News Company, manufacturers of souvenir postal cards in Boston.

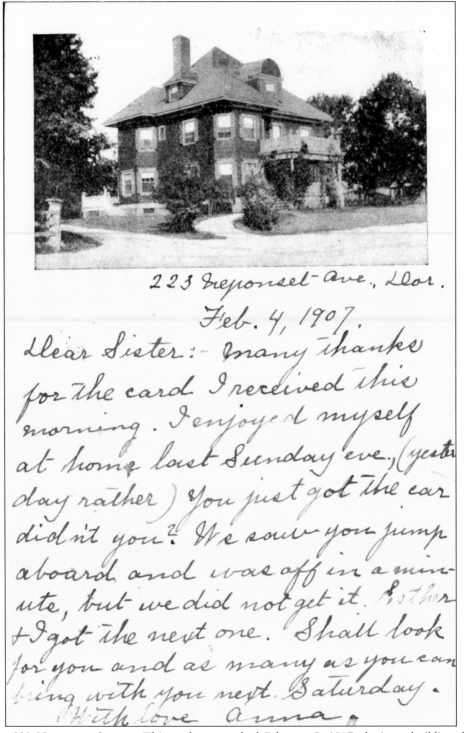

223 Neponset Ave., Dor.

Feb. 4, 1907.

Dear Sister:- many thanks
for the card I received this
morning. I enjoyed myself
at home last Sunday eve., (yester
day rather) You just got the car
didn't you? We saw you jump
aboard and was off in a min-
ute, but we did not get it. Esther
+ I got the next one. Shall look
for you and as many as you can
bring with you next Saturday.
With love Anna.

NO. 223 NEPONSET AVENUE This card, postmarked February 5, 1907, depicts a building that was converted from a private residence to the John C. Mulry Funeral Home, which operated next to St. Ann's Church until 2004.

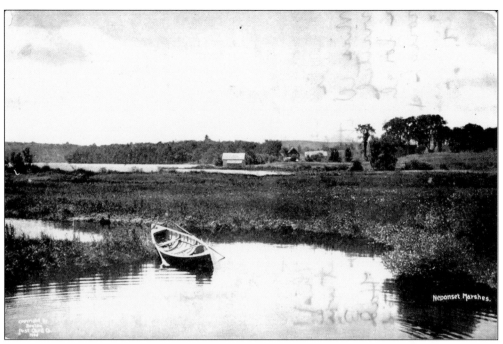

NEPONSET RIVER MARSHES. Published by the Boston Post Card Company in 1906, this card shows the Neponset River at its end, just before entering Dorchester Bay.

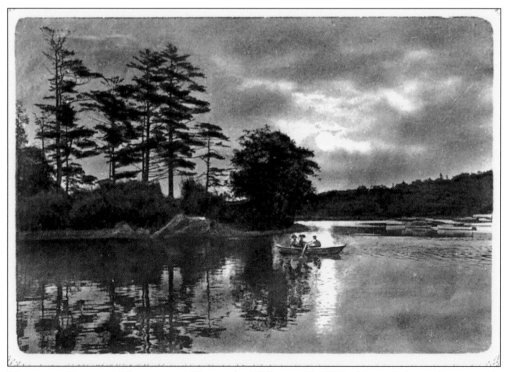

NEPONSET RIVER IN MOONLIGHT. Postmarked February 9, 1916, this card shows the romantic nature of the Neponset River. It was published by Thomson and Thomson of Boston.

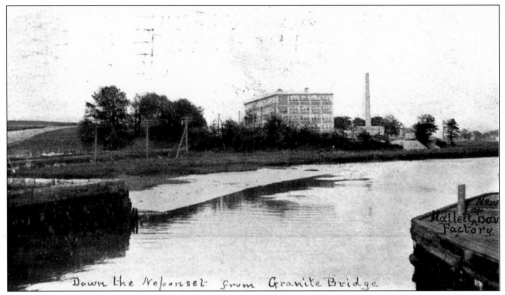

Down the Neponset from Granite Bridge

View of Hallet Dav Factory

THE KEYSTONE BUILDING. First used for piano manufacture, the Hallet and Davis building was later occupied for a time by Keystone Camera. Now called the Keystone Building, it has been converted to residential apartments.

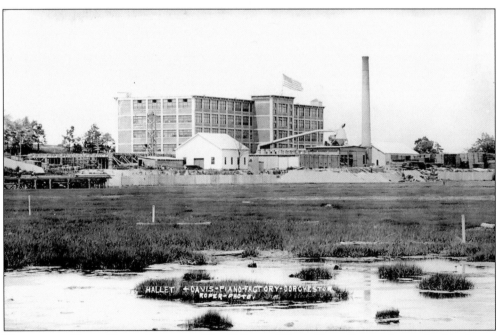

HALLET + DAVIS PIANO FACTORY DORCHESTER
ROPER PHOTO

HALLET AND DAVIS PIANO FACTORY. The Hallet and Davis Piano Factory is seen in this picture from Granite Avenue. The outbuildings have been removed and the chimney was removed in the 1990s. Currently, the land to the left is part of a new park being installed to continue the Neponset River Greenway and bicycle path.

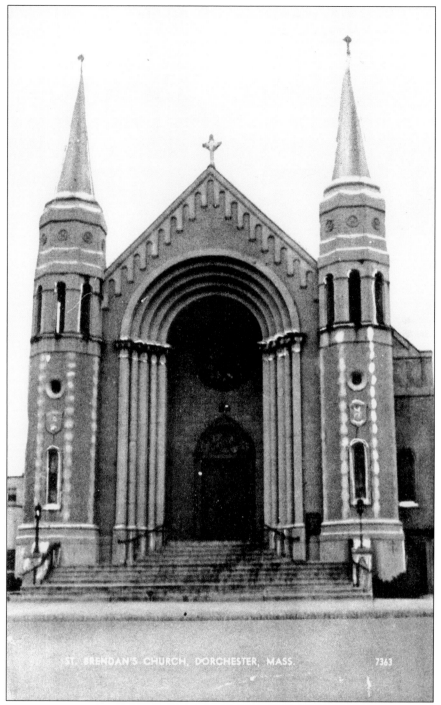

ST. BRENDAN'S CHURCH, DORCHESTER, MASS. 7363

ST. BRENDAN'S ROMAN CATHOLIC CHURCH. Created on September 25, 1929, to serve the Cedar Grove section, with territory derived partly from St. Gregory's and partly from St. Ann's of Neponset, St. Brendan's was organized under Rev. William F. Twohig, the first pastor. He held services for a time in the Granite Avenue Garage, but he proceeded quickly in erecting a brick Romanesque church on Gallivan Boulevard. The new church was blessed on November 5, 1933.

21

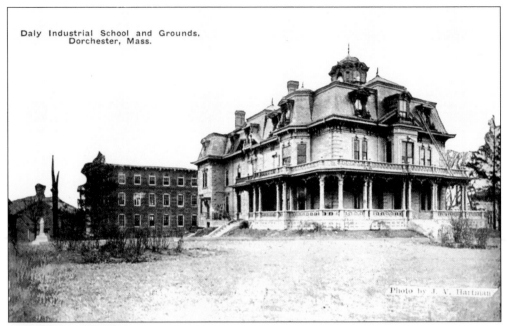

DALY INDUSTRIAL SCHOOL. This card shows the Daly Industrial School and grounds, which were located on Pope's Hill, on the west side of Train Street and the south side of Rosselerin Street.

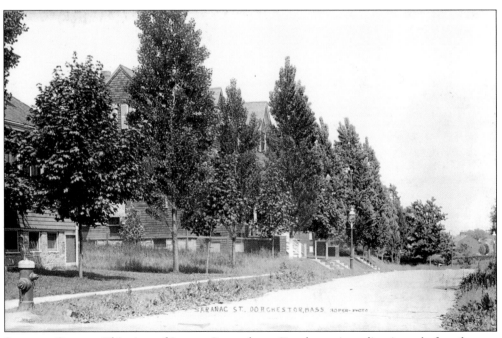

SARANAC STREET. This view of Saranac Street shows Dorchester in earlier times, before the area became heavily developed.

Two

LOWER MILLS

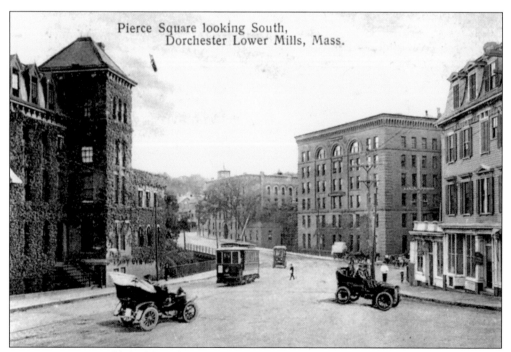

Pierce Square looking South,
Dorchester Lower Mills, Mass.

PIERCE SQUARE. Published by Thomson and Thomson, this card shows Pierce Square, in a view toward the Neponset River. Pierce Square was named for Henry L. Pierce, the executive who made Walter Baker and Company a worldwide name.

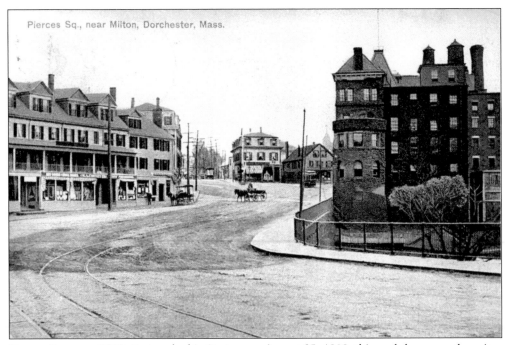

Pierces Sq., near Milton, Dorchester, Mass.

PIERCE SQUARE, 1909. Postmarked in Boston on August 25, 1909, this card shows another view of the business district at the Lower Mills on the Dorchester side of the Neponset River.

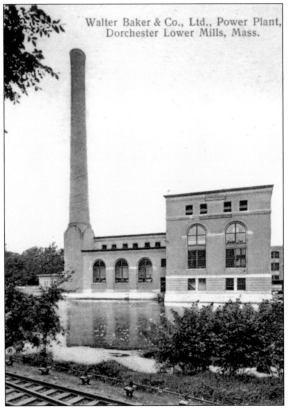

Walter Baker & Co., Ltd., Power Plant, Dorchester Lower Mills, Mass.

WALTER BAKER AND COMPANY MILLS. Published by Thomson and Thomson of Boston, this card shows the powerplant that powered the mills of the Walter Baker and Company.

POWERHOUSE, WALTER BAKER AND COMPANY. Frederick A. Frizell produced this card in 1905 to show another view of the powerhouse of the Walter Baker chocolate mills.

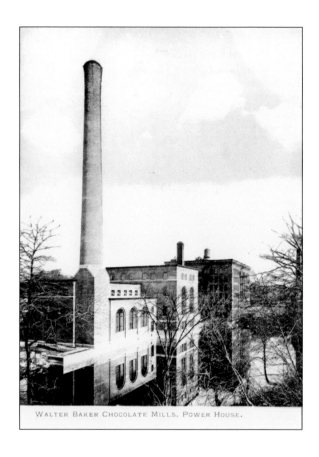

WALTER BAKER CHOCOLATE MILLS, POWER HOUSE.

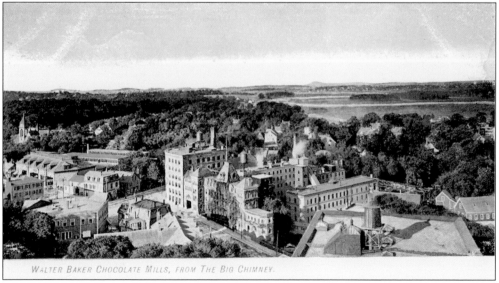

WALTER BAKER CHOCOLATE MILLS, FROM THE BIG CHIMNEY.

WALTER BAKER AND COMPANY MILLS. Frederick A. Frizell took to his camera to show this view from the top of the big chimney of the Walter Baker chocolate mills.

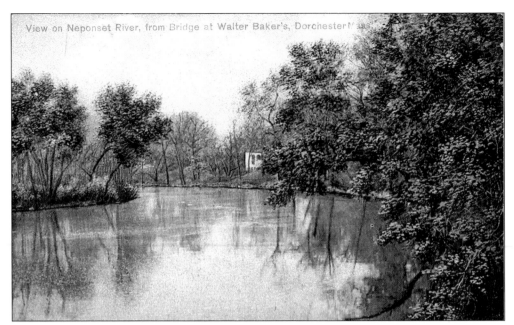

NEPONSET RIVER. Dorchester had many romantic rural views, including this one on the Neponset River. It was taken from the bridge at the Walter Baker and Company, and the card was produced by the Metropolitan News Company in Boston.

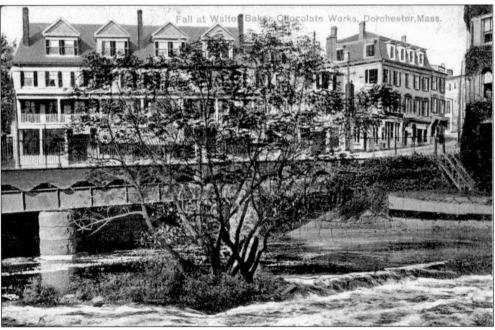

FALLS IN LOWER MILLS. One of the earliest mills in the Massachusetts Bay Colony was built here in 1634 by Israel Stoughton to grind corn obtained from the local Massachusetts tribe and from the Narragansetts. The falls continued to be an important source of power for mills of many types right up into the 20th century.

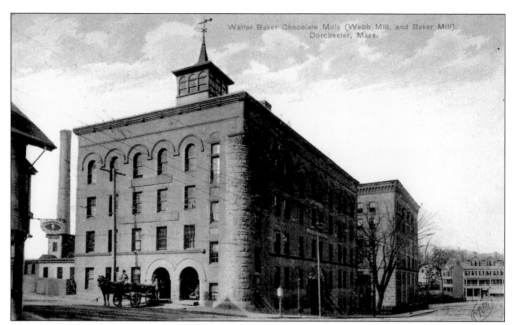

WALTER BAKER AND COMPANY MILLS. Chocolate manufacture began in Dorchester in 1765, and James Baker entered the business when he opened his first mill in 1780. By 1910, the company reported that it then comprised six mills on both sides of the Neponset River, containing 500,000 square feet of floor space—about 11.5 acres. Postmarked August 14, 1908, this card was published by the Robbins Company of Boston.

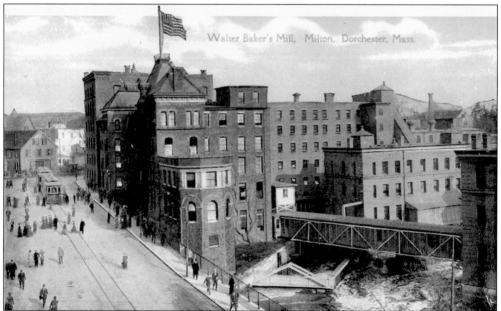

THE PIERCE MILL. The Pierce Mill stands at the intersection of Dorchester Avenue and Adams Street. The chocolate company was established by James Baker in 1780, and was later run by his son Edmund, and after him, by James's grandson Walter. This building was named for Henry L. Pierce, another member of the family, who brought the firm to national prominence. The building now houses residential apartments.

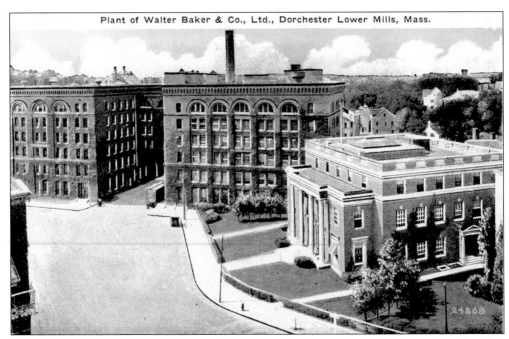

Plant of Walter Baker & Co., Ltd., Dorchester Lower Mills, Mass.

THE PLANT OF WALTER BAKER AND COMPANY. The title of this card reads, "Plant of Walter Baker & Co., Ltd., Dorchester Lower Mills, Mass." and the number 24868 is printed in the lower right corner. The card is not postmarked. The back reads, "Published by Milton Hill Pharmacy. Harry B. McCormick, Prop., Milton, Mass."

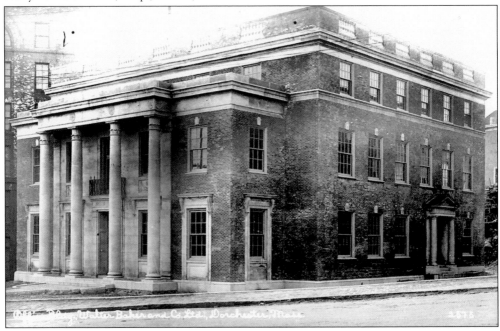

WALTER BAKER ADMINISTRATION BUILDING. Built in 1919 from the design of architect George F. Shepard for the executive offices of the company, the administration building has now become the home of artists' studios. The elegant staircase leads to a large reproduction of the painting *La Belle Chocolatiere*, the Walter Baker and Company trademark.

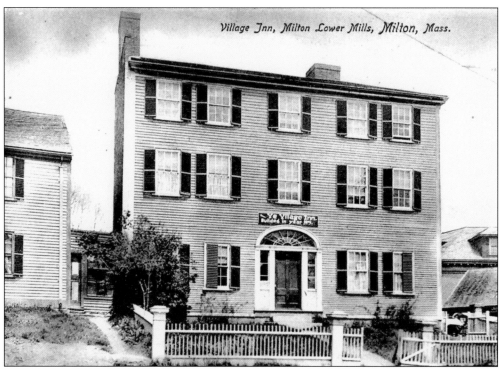

VILLAGE INN. This building stood facing Washington Street, on the corner of Dorchester Avenue. The site is now the home of Dark Horse Antiques. This card was published by the Rotograph Company of New York City.

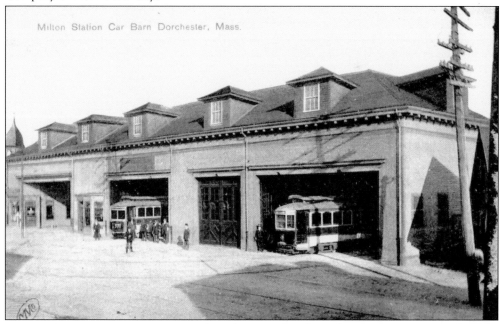

MILTON STATION CAR BARN. Located on the east side of Dorchester Avenue just north of the Lower Mills intersection, the Milton Station car barn of the Boston Elevated Railway Company was replaced by a multi-story apartment building in the second half of the 20th century.

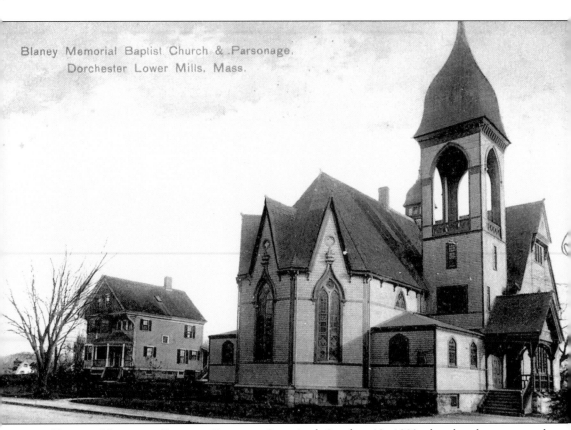

Blaney Memorial Baptist Church & Parsonage.
Dorchester Lower Mills, Mass.

BLANEY MEMORIAL BAPTIST CHURCH. Organized October 13, 1882, the church was named after Mercy Blaney who died in 1866 leaving $20,000 for the building of a church. The Blaney, which was located at the southeast corner of Dorchester Avenue and Richmond Street, was finished and dedicated March 16, 1887. The house used as the parsonage still stands and can be seen behind the parking lot of the bank building now on the corner.

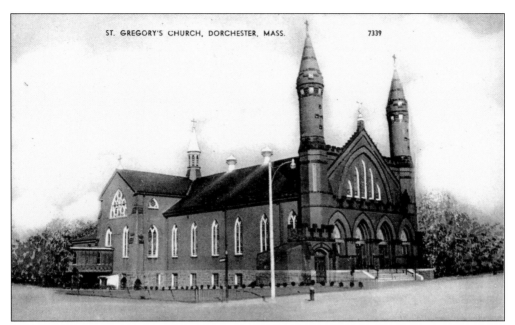

ST. GREGORY'S ROMAN CATHOLIC CHURCH. The first Catholic church in Dorchester was dedicated on April 7, 1864. In the middle of the 19th century the pastor of Saints Peter and Paul in South Boston found it difficult to serve the far-flung parish, and so he decided to establish a new church in Lower Mills under the leadership of Fr. Thomas R. McNulty.

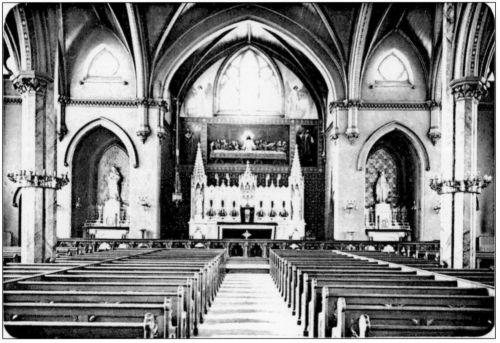

ST. GREGORY'S. St. Gregory's Roman Catholic Church acquired its two towers and the stained-glass window of St. Gregory the Great after the church was rebuilt in 1895. The title of this card reads, "St. Gregory's Church, Dorchester Lower Mills, Mass. Copyright by Thomson & Thomson, 1912." The card is not postmarked.

31

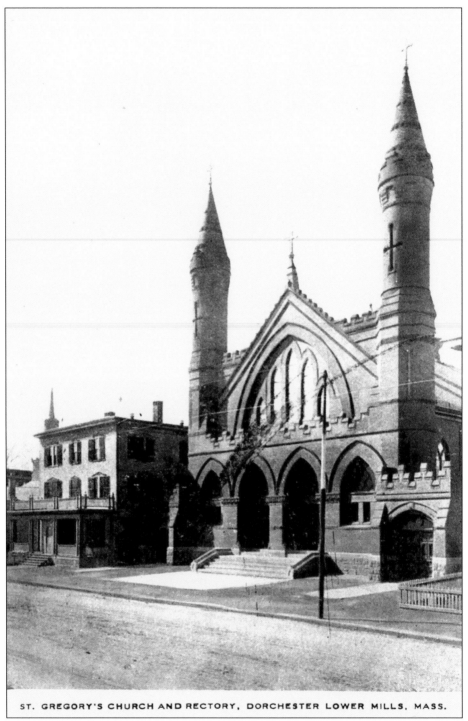

ST. GREGORY'S CHURCH AND RECTORY, DORCHESTER LOWER MILLS, MASS.

NEW PARISH. In 1862, Thomas R. McNulty became pastor of a new parish that included all of Dorchester, Milton, and Hyde Park, and a section of Quincy called Atlantic, Squantum. Soon after, construction of a new Romanesque Revival–style church building began at 2221 Dorchester Avenue.

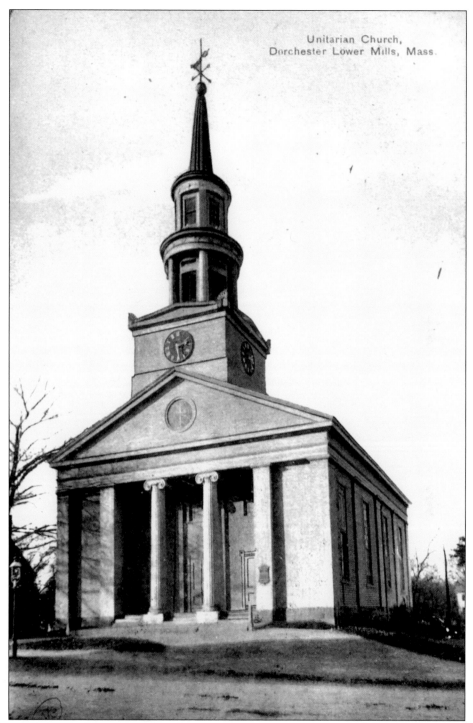

Unitarian Church,
Dorchester Lower Mills, Mass.

THIRD CHURCH, UNITARIAN. Parishioners of the Second Church who held Unitarian beliefs clashed with the conservative Rev. John Codman, resulting in the creation of the Third Church in 1813. The church building in this picture was designed in 1839 by Asher Benjamin and was located on Richmond Street at Dorchester Avenue, where the Lower Mills CVS store is now.

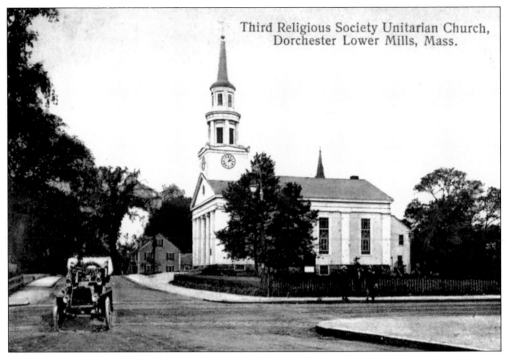

Third Religious Society Unitarian Church,
Dorchester Lower Mills, Mass.

THIRD CHURCH. The Third Religious Society completed its first church building on Washington Street in 1813, and that structure became known as Richmond Hall. This postcard view of their second building, which was constructed in 1839, was published by Thomson and Thomson of Boston.

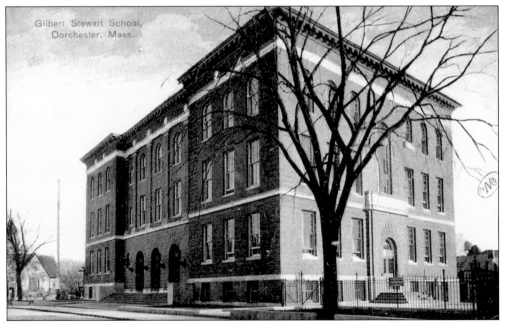

Gilbert Stewart School,
Dorchester, Mass.

GILBERT STUART SCHOOL. Built in 1896, the Stuart School, named for the artist Gilbert Stuart, stood on Richmond Street on the site of the current Lower Mills Branch Library. Copies of Stuart's paintings of George and Martha Washington once graced nearly every school in the country.

THE STUART SCHOOL. This view of the Gilbert Stuart School provides another reminder of how different Lower Mills looked at the beginning of the 20th century. At least three churches and the Stuart School provided monumental architecture and sweeping grounds in what has today become a modern, densely packed, urban setting.

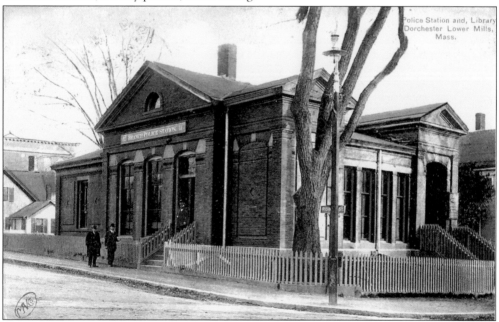

POLICE STATION AND LIBRARY. In the 1840s, this site was the location of Dr. Brewer's mansion and gardens. In 1872, the Blue Hill Bank of Dorchester moved from the Tolman Building at the corner of River and Washington Streets into the brick building seen here, located at the corner of Washington and Richmond Streets. In 1882, the city of Boston acquired the building for municipal services, and the branch library operated here until the 1970s. In the late 20th century, the building became a residential dwelling.

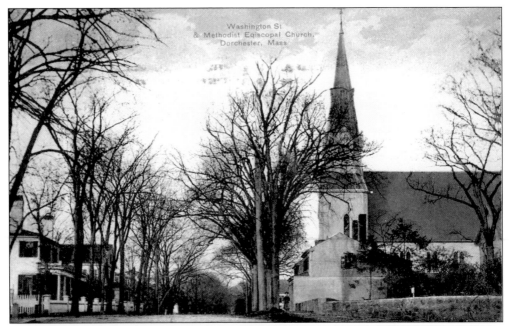

FIRST METHODIST EPISCOPAL CHURCH. In 1813, Elizabeth Simmons, Mr. and Mrs. Otheman, and Nancy Freeman lived at the corner of what is now Richmond and Washington Streets, and all were members of the First Methodist Episcopal Church in Boston. Soon after Mr. Otheman arrived, he invited neighbors to his home for religious services. Mr. Otheman's house was stoned, and the churchgoers were at first maligned, ridiculed, insulted, and assaulted by those who did not appreciate the new sect. In the year 1816, Anthony Otheman, supported by Elizabeth Simmons, conducted the first services and formed the first class meetings. The congregation built their third church building, designed by A. P. Cutting in the wooden Gothic style, at this location in 1874.

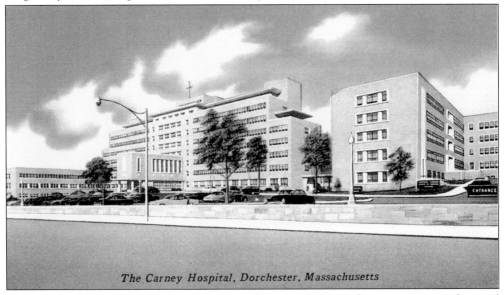

CARNEY HOSPITAL. Originally founded in South Boston in 1863, the Carney Hospital moved to Dorchester in 1953. Opened on November 27, 1953, the new facility was a 315-bed general hospital operated by the sisters of St. Vincent de Paul.

Three

PEABODY SQUARE, CODMAN SQUARE, AND ST. MARK'S

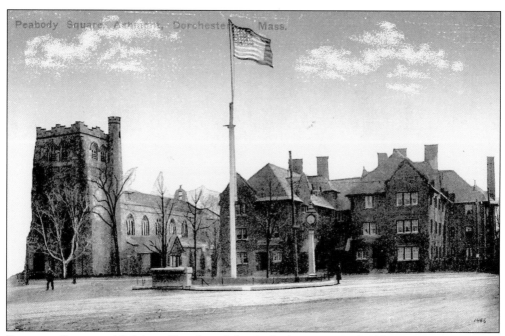

PEABODY SQUARE. All Saints Church and the Peabody apartment building are located on the south side of Peabody Square. The Peabody apartment building was designed by Edwin J. Lewis, who also designed many distinguished houses in Dorchester. The Peabody Square clock, designed by architect W. D. Austin and erected in 1910, is clearly visible in this postcard.

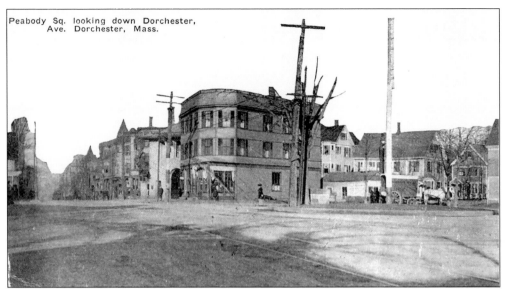

Peabody Sq. looking down Dorchester,
Ave. Dorchester, Mass.

BIRTH OF PEABODY SQUARE. Peabody Square grew out of a crossroads on the South Boston turnpike. The turnpike was laid out in 1805 between Milton Lower Mills and the bridge crossing Dorchester Neck into Boston. The turnpike was used mainly by stagecoaches until it was made free by private subscription in 1854, and in 1856–1857 a track for horsecars was laid. Later accepted as a public highway by the town, it is the present Dorchester Avenue. This card, which was postmarked August 12, 1911, was published by J. V. Hartman and Company of Boston.

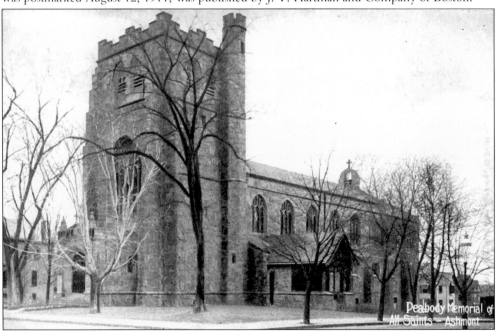

ALL SAINTS EPISCOPAL CHURCH. All Saints began in 1867 as a mission of St. Mary's Church. The first meetings were held in American Hall in Lower Mills, and in the 1870s, a mission church was built on Washington Street near Lower Mills. Col. Oliver Peabody and wife Mary contributed the money to have the church moved down Dorchester Avenue to Ashmont, and they later contributed $80,000 of the $115,000 needed to build the new stone church in Peabody Square.

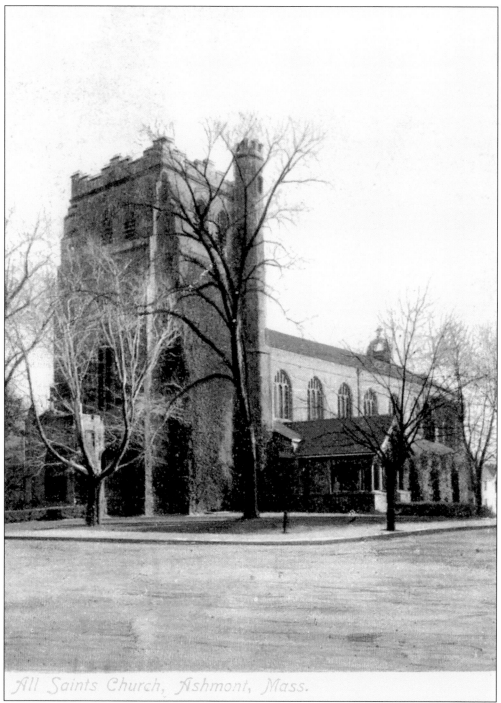

All Saints Church, Ashmont, Mass.

ALL SAINTS. Designed by Ralph Adams Cram of Cram, Wentworth, and Goodhue, the All Saints building was completed in 1893 and the tower was finished in 1894. All Saints is a significant landmark in American architectural history and became a model of modern American Gothic architecture for designers of American churches for the next 50 years. It has been called Cram and Goodhue's masterpiece.

39

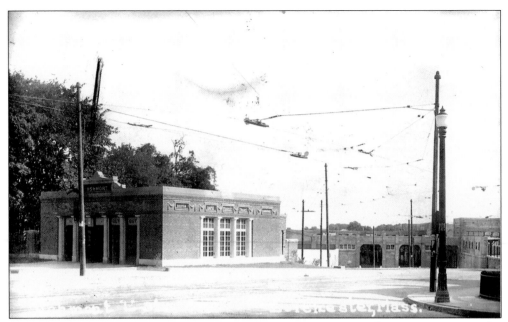

ASHMONT STATION. Shown here in a real-photo postcard *c.* 1930, Ashmont Station is similar to other Red Line subway stations in its design. This Ashmont Station building stood until the 1970s, when it was replaced by a modern shed that is once again undergoing significant repair and change.

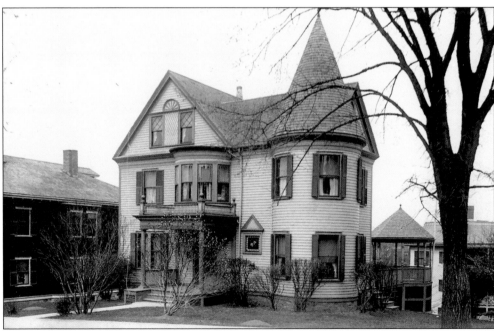

NO. 87 ALBAN STREET. This real-photo postcard of 87 Alban Street shows the suburban character that has been preserved in many of Dorchester's neighborhoods.

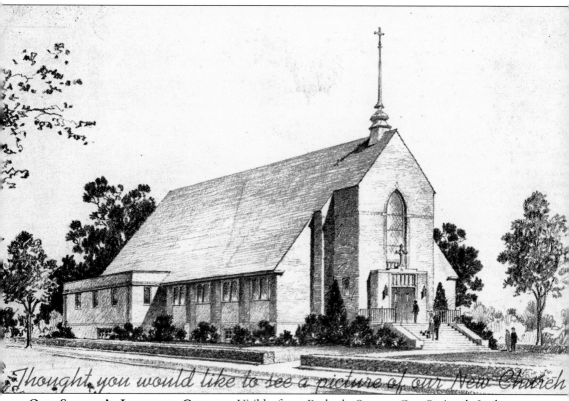

Thought you would like to see a picture of our New Church

OUR SAVIOUR'S LUTHERAN CHURCH. Visible from Peabody Square, Our Saviour's Lutheran Church (originally called the Vasa Lutheran Church) is located at 500 Talbot Avenue on a prominent triangle of land between Talbot Avenue and Argyle Street. This drawing was done prior to construction in 1949.

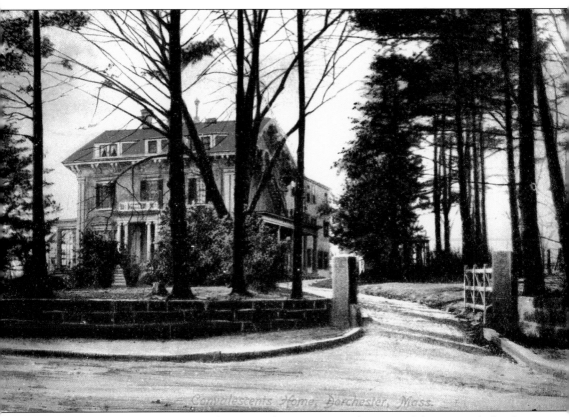

Convalescents Home, Dorchester, Mass.

THE BOSTON HOME. Located on Dorchester Avenue between Ashmont and the Lower Mills, the Home for Incurables—or the Boston Home—which moved to its new building in Dorchester in 1885, concentrates today on the treatment of multiple sclerosis and related neurological conditions.

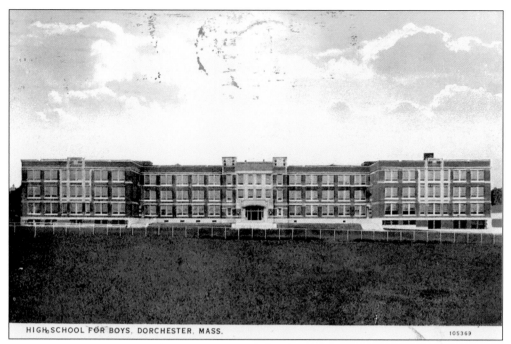

HIGH SCHOOL FOR BOYS, DORCHESTER, MASS.

105369

HIGH SCHOOL FOR BOYS. This building is now the Dorchester High School, which like other city schools, serves students from all over the city of Boston.

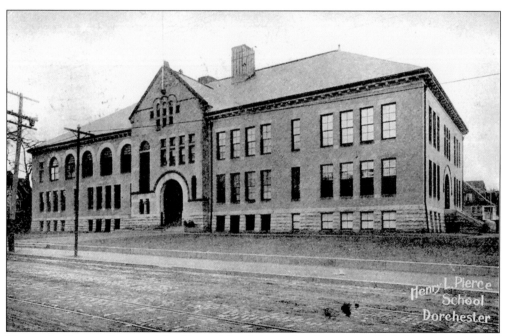

HENRY L. PIERCE SCHOOL. The Pierce School, located at the corner of Washington Street and Welles Avenue, was dedicated in 1892 and was demolished in the 1970s, to be replaced by the current Codman Square branch of the Boston Public Library in 1975. The Welles mansion stood on this site from the mid-18th century until the Pierce School was built.

43

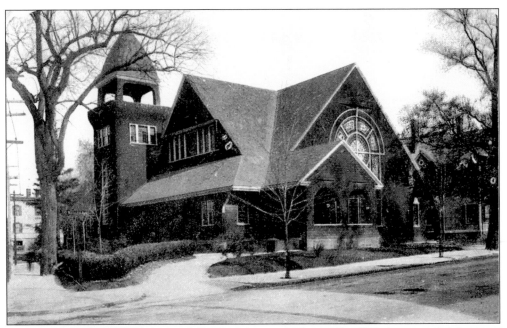

DORCHESTER TEMPLE BAPTIST CHURCH. Built during the years 1889–1892 at the corner of Washington Street and Welles Avenue, the Dorchester Temple Baptist Church was designed by architect Arthur H. Vinal in the Shingle style. This card, which was postmarked at Dorchester Center on January 2, 1909, was published by the New England News Company of Boston.

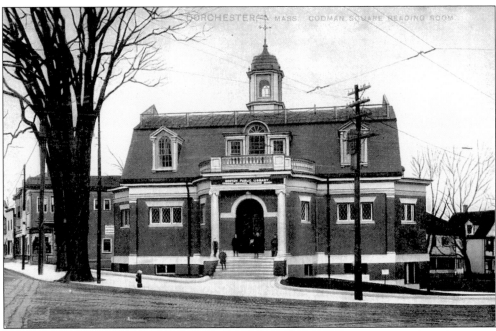

CODMAN SQUARE LIBRARY. Codman Square's first branch of the Boston Public Library was built in 1906 on the site of the former town hall. The new building served the community by providing various city services, including dentistry.

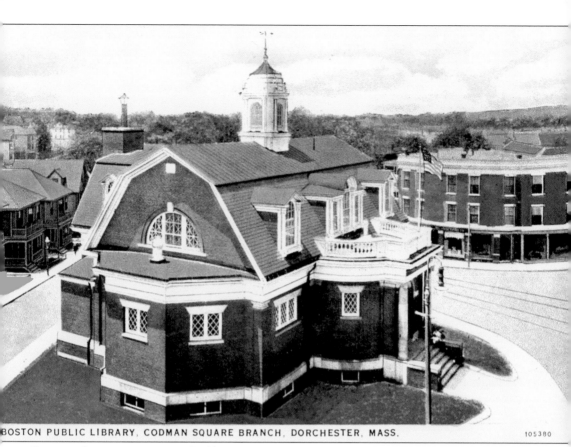

BOSTON PUBLIC LIBRARY, CODMAN SQUARE BRANCH, DORCHESTER, MASS. 105380

CODMAN SQUARE LIBRARY. The library acquired a new building in the 1970s at the corner of Washington Street and Welles Avenue. The city of Boston continues to own this building, and now leases it to the Codman Square Health Center. Its design is in Colonial Revival style with a cupola, and originally it had a Chinese Chippendale roof balustrade. The health center restored its great hall, which is now open for community meetings.

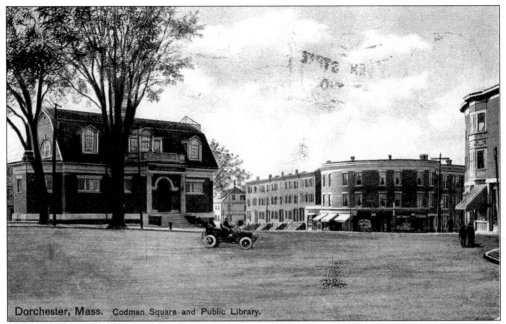

Dorchester, Mass. Codman Square and Public Library.

CODMAN SQUARE. Codman Square began as Baker's Corner, taking its name from Dr. James Baker's store. In 1848 the intersection was renamed Codman Square for Rev. John Codman, who had died the previous year after serving 39 years as the pastor of the Second Church. This card, which was postmarked December 21, 1909, was published by the Hugh C. Leighton Company of Portland, Maine.

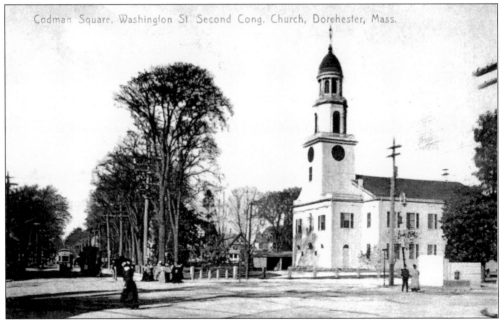

Codman Square, Washington St Second Cong. Church, Dorchester, Mass.

NORTH VIEW OF CODMAN SQUARE. This card is a northward view of Codman Square, showing Dorchester's Second Church of Federal meetinghouse style. The architect is unknown, but the building was constructed in 1804–1805, and it was dedicated in 1806. The trolley car in the distance is traveling north along Washington Street.

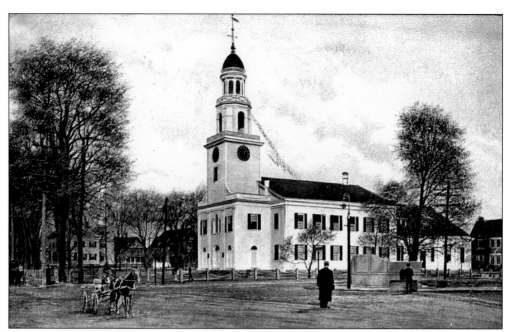

SECOND CHURCH. The Second Parish was formed by vote of the town of Dorchester on June 19, 1807. The church was organized by a council on January 1, 1808, with 64 charter members "affectionately dismissed" from the First Church. The new church building was dedicated October 30, 1806, and Rev. John Codman became its first pastor in December 1808. It became known as the South Church, and when part of its congregation split to form the Third Church, that new church became known as New South.

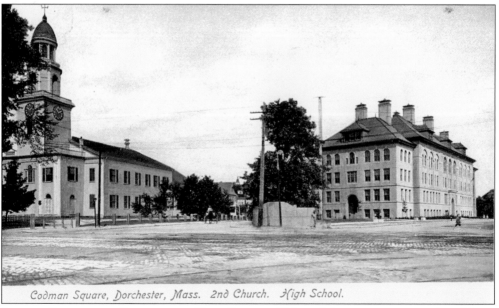

Codman Square, Dorchester, Mass. 2nd Church. High School.

SECOND CHURCH AND DORCHESTER HIGH SCHOOL. This card shows two ever-popular subjects: the Second Church and Dorchester High School. After the turn of the 20th century, Codman Square became criss-crossed with trolley tracks, and like other major intersections, it had a car barn, where the trolley cars were kept overnight.

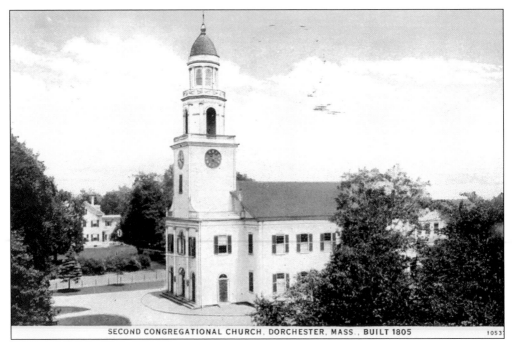

SECOND CONGREGATIONAL CHURCH, DORCHESTER, MASS., BUILT 1805 1053

SECOND CONGREGATIONAL CHURCH. The Second Congregational Church was built in the years 1805 and 1806. Its bell was manufactured by the Paul Revere Company and was installed in 1816.

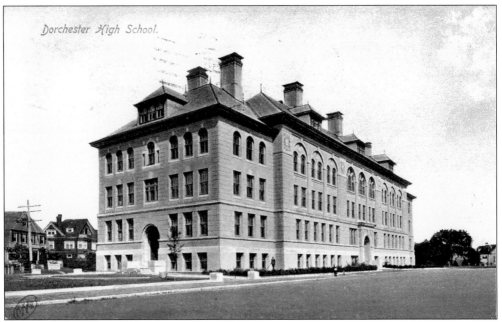

Dorchester High School.

DORCHESTER HIGH SCHOOL. Dorchester High School, located at the corner of Talbot Avenue and Centre Street, was designed by Hartwell, Richardson, and Dyer in the Renaissance Revival style and was built in 1895. It later became Girls' Latin School, then Boston Latin Academy, and now houses the Latin Academy Apartments.

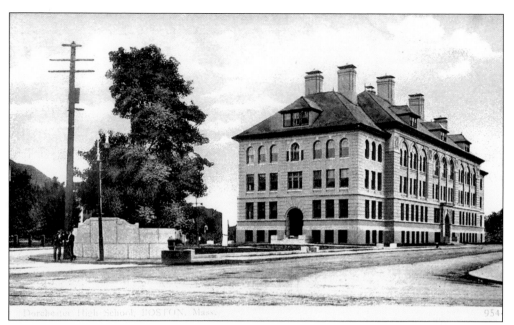

PRIDE OF THE NEIGHBORHOOD. The many postcard views of Dorchester High School are a tribute to its popularity as a subject for the photographer's camera, and to the pride of the residents of Dorchester in the construction of this monumental building.

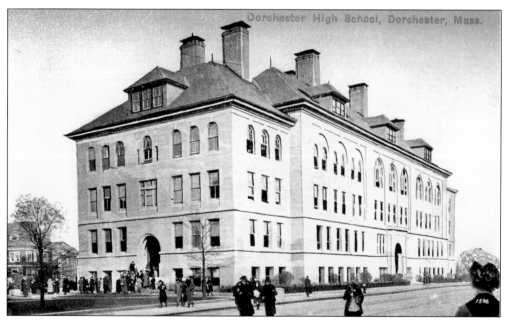

TILED ENTRANCE. The entrance to Dorchester High School has a tile design in the floor, originally a section of the "Fosse" or Roman Way laid by the Romans in Dorchester, England, after they had subjugated the Britons in 55 B.C. The Roman Way was discovered when the crypt of All Saints Church in Dorchester, England, was being repaired. It is composed of red and white cubes of various sizes enclosed within a brass border and is almost 10 feet long and 6 feet wide, comprising almost 9,000 blocks.

49

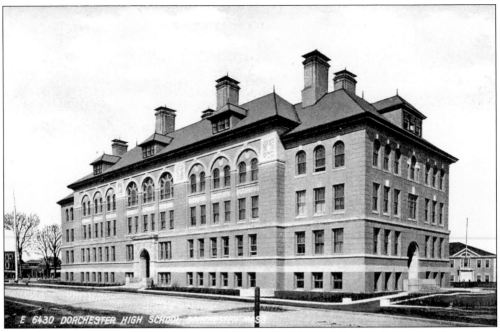

FIRST FREE PUBLIC SCHOOL. Dorchester claims the first free public school supported by a direct tax upon the people. On May 20, 1639, it was ordered that there shall be a rent of 20 pounds yearly forever imposed upon Thompson's Island to be paid by every person that hath property in said island.

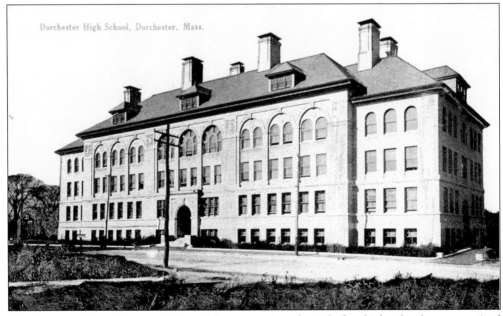

DORCHESTER HIGH SCHOOL'S THIRD BUILDING. Dorchester's first high school was organized in December 1852, with a membership of 59 pupils. This, the third high school building, was constructed in 1895 at a cost of $250,000 and was designed for over 350 students.

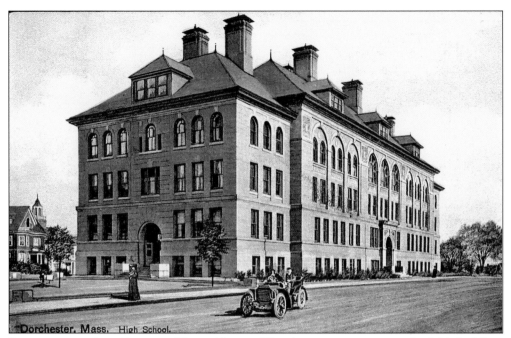

STATE-OF-THE-ART FACILITY. The residents of Dorchester were very proud of this building, which boasted a gymnasium of over 5,500 square feet with a visitors gallery seating 125 persons. The building was state of the art at the time, with laboratories, library, recitation rooms, shower-baths, and dressing rooms.

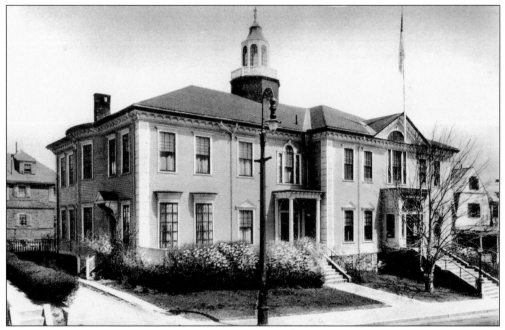

DORCHESTER WOMAN'S CLUB. The Dorchester Woman's Club promoted moral, social, and intellectual culture in the community. The group's building was designed in the Colonial Revival style by local architect A. Warren Gould.

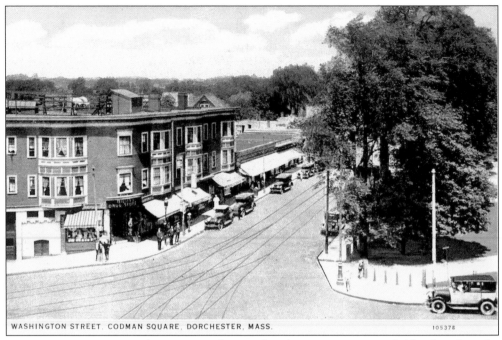

WASHINGTON STREET, CODMAN SQUARE, DORCHESTER, MASS. 105378

CODMAN SQUARE, 1920. This 1920s aerial view of Codman Square was probably taken from the roof of the Lithgow Building. It shows the land in front of the Second Church and the business block across the street, where McDonald's now has a restaurant.

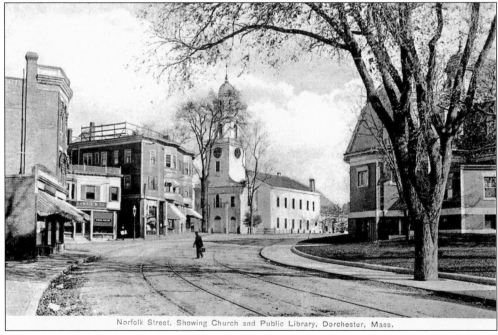

Norfolk Street, Showing Church and Public Library, Dorchester, Mass.

NORFOLK STREET. Published by T. E. Cushing of Dorchester, this card shows the Talbot Avenue approach to Codman Square, with the library building on the right and the Second Church in the center.

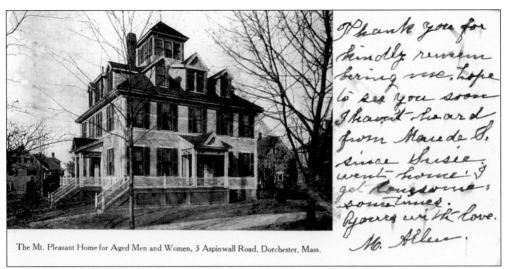

Thank you for kindly remembering me. Hope to see you soon. I haven't heard from Maude S. since Susie went home. I get lonesome sometimes. Yours with love. M. Allen.

The Mt. Pleasant Home for Aged Men and Women, 3 Aspinwall Road, Dorchester, Mass.

MOUNT PLEASANT HOME. The Mount Pleasant Home for Aged Men and Women, located at 3 Aspinwall Road, serves as an example of the many Dorchester organizations intended to help people in all types of needs.

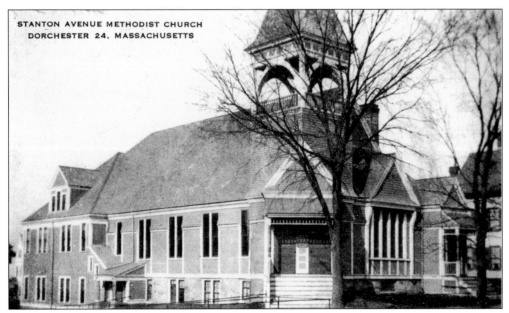

STANTON AVENUE METHODIST CHURCH
DORCHESTER 24, MASSACHUSETTS

STANTON STREET METHODIST CHURCH. In the spring of 1886, prayer meetings were held in a private house on Maxwell Street. These meetings drew interest, and later were moved to a grove on Pine Hill on Maxwell Street. In response to a demand for a church building, a lot was secured, and a church was planned to be built in the Queen Anne style, measuring 65 feet by 40 feet. The building was opened in July 1887 as the Stanton Avenue Methodist Episcopal Church at the corner of Stanton and Evans Streets. The building is now the Zion Temple Holy Church.

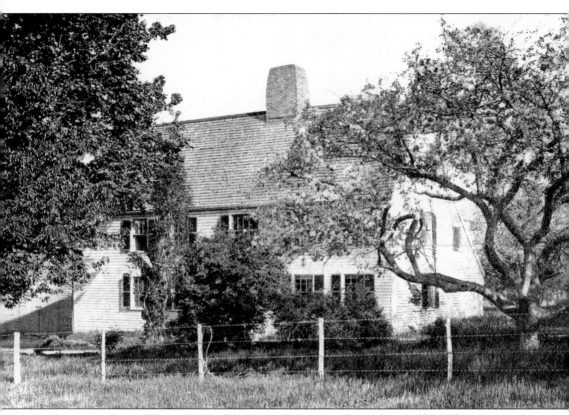

BARNARD CAPEN HOUSE. Barnard (or Bernard) Capen, a shoemaker, and his wife, Joan (Purchase) Capen, arrived in Dorchester in 1633. They built this house, in the 1630s, on Washington Street across from Melville Avenue, at the corner of Washington Street and Dunlap Road. The home remained in the Capen family for nearly 270 years. In 1909 the house was threatened with demolition to make way for a development of three-deckers. It was then that Harvard professor Kenneth Grant Tremayne Webster paid $50 to purchase the house so that it could be relocated and preserved. Drawings were made, and every board, brick, and timber in the structure was numbered for accurate reassembly. The house was reconstructed at 427 Hillside Street in Milton, near Houghton's Pond, where it still stands today. The original house, considered to be the second-oldest house in New England, was built in the style of the West Country with heavy framing. Barnard Capen's is the oldest marked grave in Massachusetts.

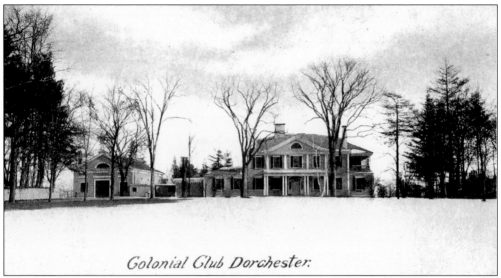

Colonial Club Dorchester.

Colonial Club. Built in 1737 by Lt. Gov. Andrew Oliver at what is now the corner of Washington Street and Park, this house stood into the 20th century, when it was used by the Colonial Club. Oliver lived there until 1782, when Col. Benjamin Hichborn purchased it to use as a summer residence until 1817. While he owned the house, Hichborn entertained General Lafayette there in 1783, and later President Monroe. James Penniman, who occupied the house in 1830, was interested in founding the Dorchester Academy, and he allowed the parlor to be used as a schoolroom for a time. Shortly thereafter, Walter Baker came into possession of the property. He died in 1852, and his widow lived there till her death in 1891.

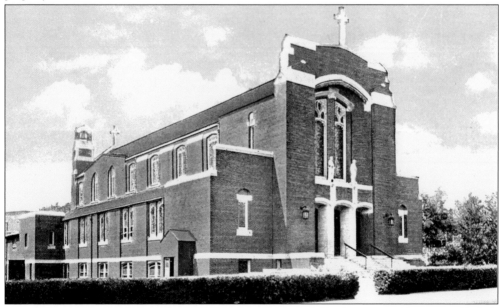

St. Mark's Roman Catholic Church. In 1899, Father Fitzpatrick of St. Gregory's bought a piece of land at Dorchester Avenue and Rosemont (now Roseland) Street and built a chapel. Note that Rosemont at that time included what is now Roseland, St. Mark's Road, Semont, Greenrose, and Rosemont Streets. In 1905, St. Mark's Parish was set off from St. Gregory's, and in 1914, the parish commissioned Charles Brigham to design this red brick church in perpendicular Gothic style.

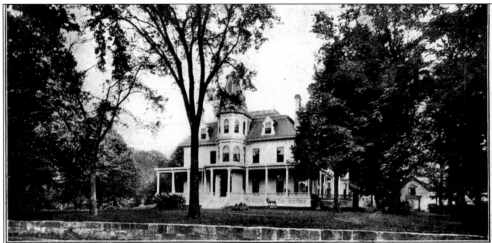

DR. DOUGLAS' SANATORIUM, 321 Centre Street, Dorchester, Mass. Near Field's Corner.

I am sending you a reprint from the N.Y. "Medical Record" of Dr. Douglas' article on "Dipsomania."

H. X. R.

DR. DOUGLAS' SANATORIUM. Located at 321 Centre Street, near Field's Corner, this house was built by city alderman Charles V. Whitten. Its porch wrapped around all four sides of the house. The house is gone and the site is now occupied by the St. Joseph Home, a large brick building.

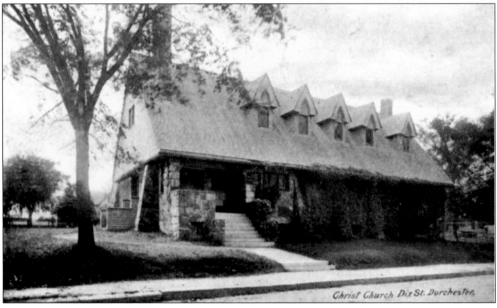

Christ Church Dix St. Dorchester.

CHRIST CHURCH. Christ Church of Dorchester was organized in 1852 as the Third Unitarian Society, and was known from 1875 to 1894 as the Harrison Square Unitarian Church. The congregation relocated from a building at the corner of Neponset Avenue and Mill Street to this building, which was designed by Edwin J. Lewis Jr., at the corner of Dorchester Avenue and Dix Street. The original design included a tower that was never built. Lewis is most famous for his residential architecture and some of his designs are located in Dorchester, including 15 and 22 Carruth Street, 12 Alban Street, as well as 12, 60, and 75 Ocean Street.

Four

HARRISON SQUARE
TO FIELD'S CORNER

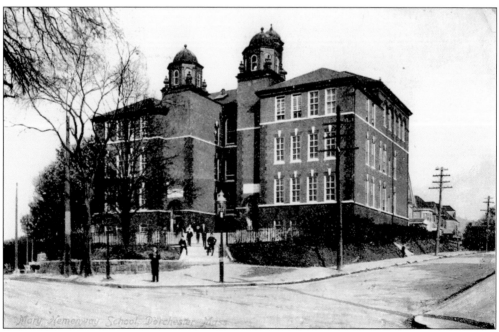

MARY HEMENWAY SCHOOL. Located at the corner of King and Adams Streets, the Mary Hemenway School was named for philanthropist Mary Hemenway, who was a descendant of the Tilestons, one of Dorchester's earliest families.

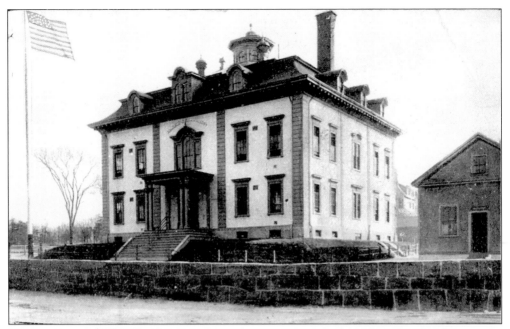

HARRIS SCHOOL. The Harris School, named for Rev. Thaddeus Mason Harris, who was the pastor of the First Parish for many years, was built at the corner of Adams Street and Victory Road (formerly Mill Street) in 1861. In the latter half of the 20th century, the property was sold to the Boston Housing Authority for the construction of apartment buildings.

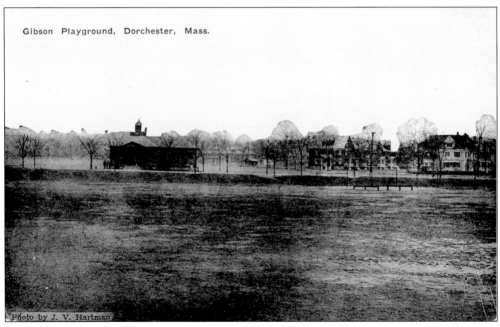

Gibson Playground, Dorchester, Mass.

Photo by J. V. Hartman

GIBSON PLAYGROUND. Now also called Town Field, this playground was named for Christopher Gibson, one of the original settlers in 1630, who was a soap boiler by trade. He served as a selectman in 1636, 1638, and 1642, and in his will he left over 100 pounds to the town for the promotion of learning.

58

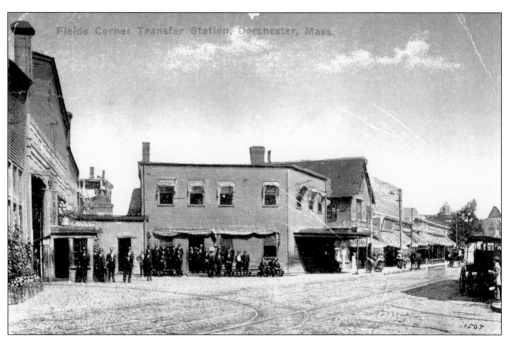

FIELD'S CORNER. Field's Corner had its own car barn for the storage of trolley cars. In this card, postmarked August 1918, the trolley tracks turn from Dorchester Avenue into the barn.

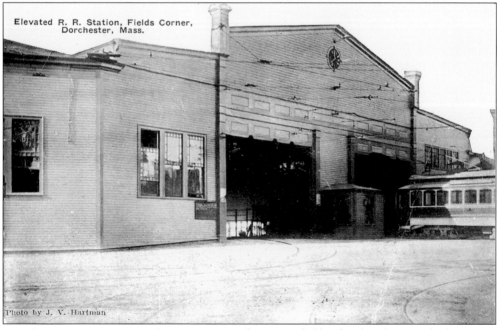

FIELD'S CORNER TRANSFER STATION. Any subject was fodder for the photographer's camera, and trolley cars were a major feature of the street landscape in the early 20th century.

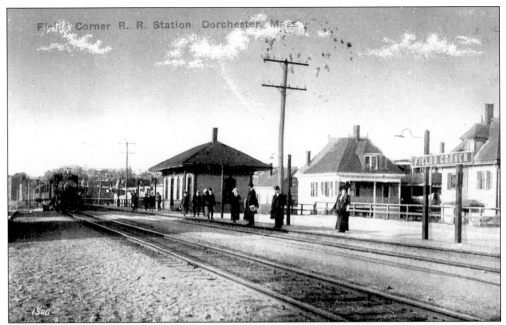

FIELD'S CORNER RAILROAD STATION. In the early 1920s, the train for commuters traveling into Boston stopped at Field's Corner, a station at grade level. This picture was taken before the creation of today's system, which travels underground in some areas and on elevated tracks in others.

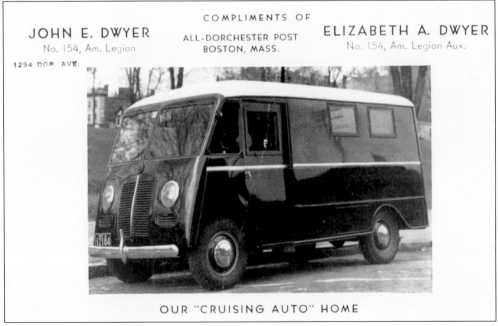

AMERICAN LEGION. The all-Dorchester post of the American Legion, located at 1294 Dorchester Avenue, introduced a little humor by publishing this card of their "Cruising Auto Home" *c.* 1940.

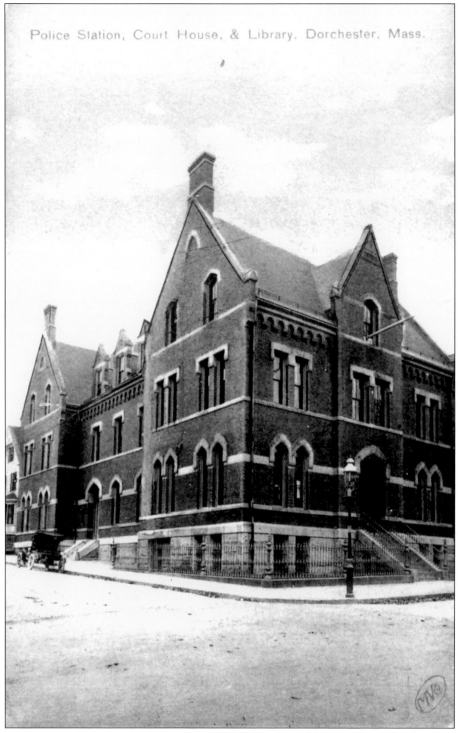

Police Station, Court House, & Library, Dorchester, Mass.

POLICE STATION. The municipal building at Field's Corner, which was located at the corner of Adams and Arcadia Streets, was designed by city architect George Clough, and construction was completed in the 1870s. It served as the police station and branch library.

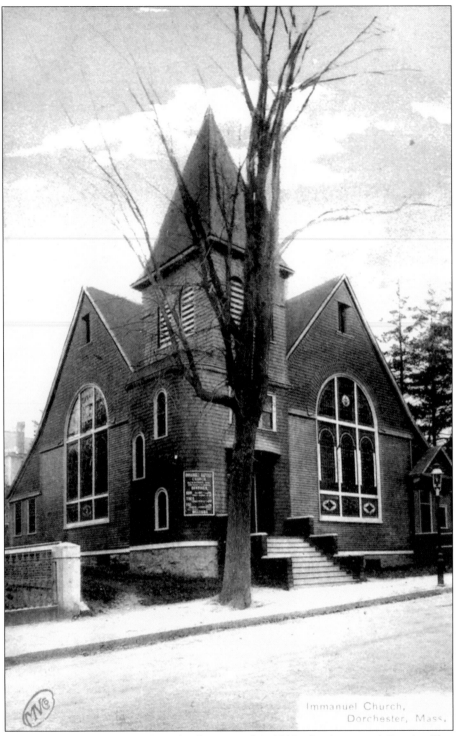

Immanuel Church,
Dorchester, Mass.

IMMANUEL BAPTIST CHURCH. Organized January 26, 1897, the Immanuel Baptist Church's building was located at 191 Adams Street, next to the municipal building in Field's Corner. Today the site is a parking lot.

Five

MEETING HOUSE HILL

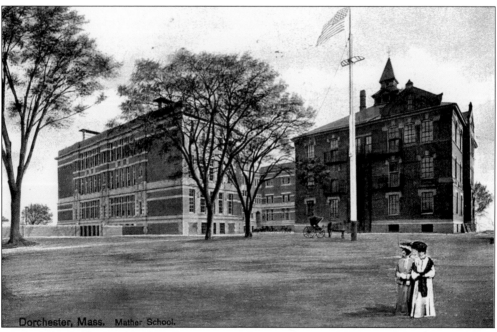

Dorchester, Mass. Mather School.

MATHER SCHOOL. The new Mather School, seen on the left, was built in 1905 from the design of architects Cram, Goodhue, and Ferguson. The old Mather School, built in the 19th century and still standing in this view, has since been demolished. The Mather School, the oldest free public school supported by a direct tax in North America, is named for Richard Mather, an English clergyman who immigrated to Boston in 1635 and was invited to become the pastor in Dorchester. He contributed the preface and the versification of several psalms in the *Bay Psalm Book*, which was the first book printed in the American Colonies.

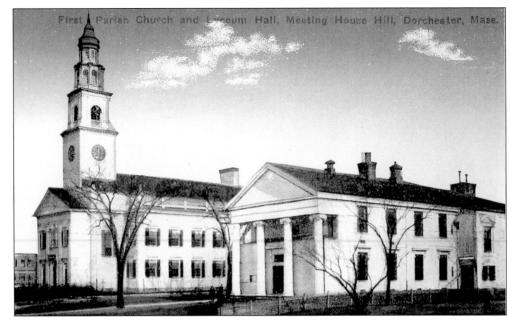

FIRST PARISH CHURCH. The First Parish Church (Unitarian), located on Meeting House Hill in Dorchester district, is the oldest religious society in Boston. It was organized in Plymouth, England, on March 20, 1630, the eve before the embarkation of the first settlers of Dorchester in the *Mary and John*. Along with the Colonists, the ship carried John Maverick and John Warham as pastors of their church, which was transferred to America through the sailing of all its members.

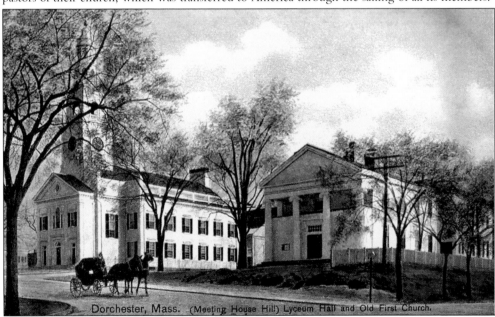

Dorchester, Mass. (Meeting House Hill) Lyceum Hall and Old First Church.

MEETING HOUSE HILL. Lyceum Hall was constructed in 1840 in the Greek Revival style and was used as a public meeting hall. Over the years, it served as the location for the firemen's balls, dance classes, Sunday school, a recruiting depot for Union forces in the Civil War, and other events. The building became a special-needs school for the city of Boston by 1891, and it was demolished in 1955.

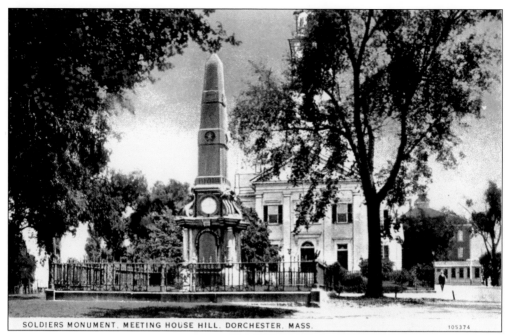

SOLDIERS MONUMENT, MEETING HOUSE HILL, DORCHESTER, MASS. 105374

PICKWICK CLUB. Twenty-one members of the Pickwick Club served the Union Army in the Civil War. To honor all of Dorchester's Civil War dead, the club established a memorial monument across from the First Parish Church. The literary and debating club was named after characters in Charles Dickens's fiction to celebrate the author's visit to Boston.

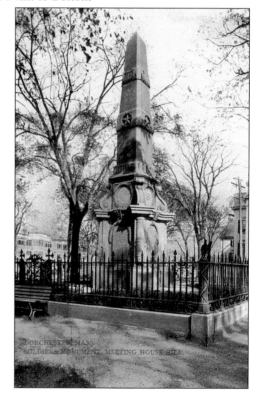

SOLDIERS' MONUMENT. Made of rose-colored Gloucester granite, the monument measures about 8 feet wide at the base and is 31 feet tall. It has the inscription "In Honor of the Citizen Soldiers of Dorchester Who Fell in the War of the Rebellion, 1861–1865." It also displays the seal of the town and the motto, "They Died that the Nation Might Live."

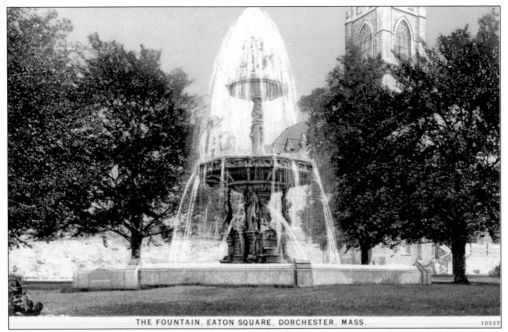

THE FOUNTAIN, EATON SQUARE, DORCHESTER, MASS. 10537

LYMAN MEMORIAL FOUNTAIN. The impetus for the erection of the fountain at Eaton Square came from Nahum Capen, who said, "As Theodore Lyman Jr., was the first to propose the introduction of water into the city of Boston, I felt that properly a monument to his memory would be a Fountain."

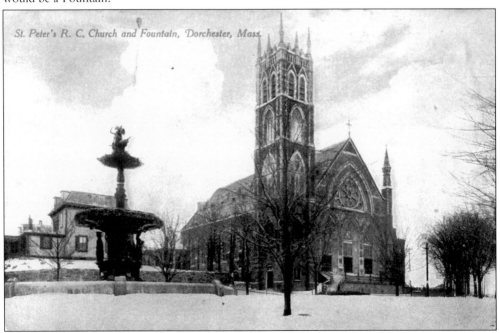

St. Peter's R. C. Church and Fountain, Dorchester, Mass.

ST. PETER'S ROMAN CATHOLIC CHURCH. In 1872, Fr. Peter Ronan, then 28 years old, was assigned to Dorchester by Bishop John Joseph Williams. Father Ronan said his first Mass in Lyceum Hall, and he made plans for the construction of a church building at Percival and Bowdoin Streets. He lived in a cottage on the church property.

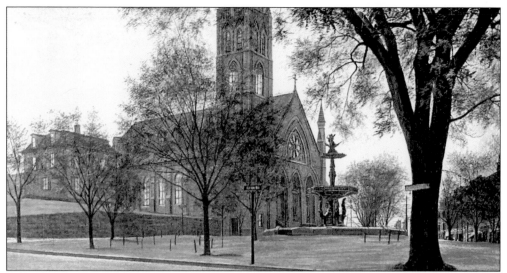

LYMAN MEMORIAL FOUNTAIN. Postmarked at Dorchester Center Station in May 1911, this card was published by the Hugh C. Leighton Company of Portland, Maine. The fountain, designed and constructed of bronzed iron and zinc by M. D. Jones of Boston, was 26 feet high, and its basin was 33 feet in diameter. The surmounting group of figures represented Venus, Cupid, and a swan, while the figures about the pedestal stood for the four seasons. One of the pipes discharged water through the swan's mouth, as well as through four dragons on the first pedestal and four griffins between the first and second pans.

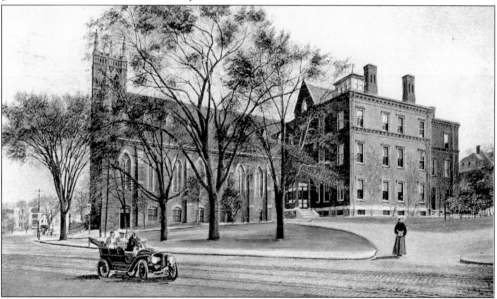

ST. PETER'S ROMAN CATHOLIC CHURCH. The bishop had already selected a lot of land and had accepted architect's designs for a new church before he assigned Fr. Peter Ronan to Dorchester. Father Ronan's suggestion to discard the plans and to secure the services of the famous architect Patrick Keely seemed audacious on the part of so young a priest, but Father Ronan had his way. The cornerstone was laid in August 1873, and the upper church was dedicated on February 18, 1884. In 1891, the grand square tower, visible for many miles around, was completed with the addition of the beautiful finials at the top.

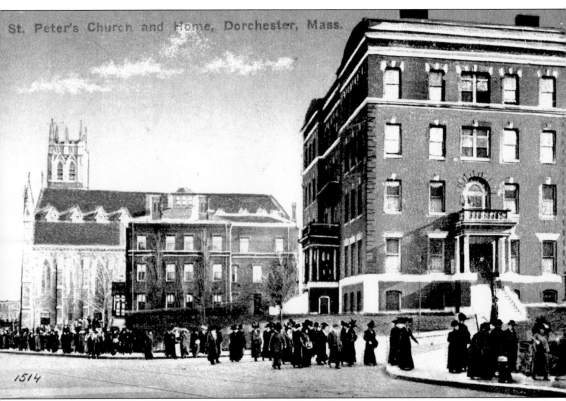

St. Peter's Church and Home, Dorchester, Mass.

1514

THE RECTORY. In 1886, the three-story brick rectory, also designed by Patrick Keely, was finished on a lot of land on the west side of the church that was purchased from Nahum Capen. Offices, parlors, a dining room, and a kitchen occupy the first floor, and there are apartments above for the pastor and his assistants.

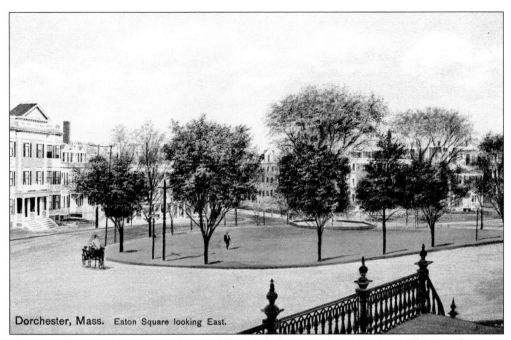

Dorchester, Mass. Eaton Square looking East.

PERCIVAL EATON. Eaton Square is named for Percival Eaton. From the time of the Revolution to the Civil War, Percival Eaton, and later his son, Ebenezer Eaton, kept a tavern directly opposite what is now St. Peter's Church.

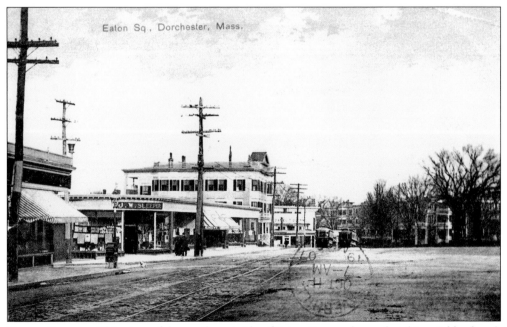

Eaton Sq., Dorchester, Mass.

EATON SQUARE. This view of the northwest side of Eaton Square shows that this neighborhood, like most in Dorchester, always had a mix of residential and commercial buildings. Trolley cars appear in pictures of nearly every neighborhood, demonstrating how important mass transportation became in a short time.

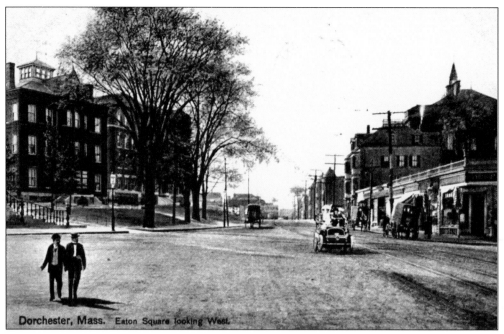

VIEW OF EATON SQUARE. St. Peter's Church Parsonage and Convent can be seen on the left, and the parochial school is behind the storefronts on the right. St. Peter's Church itself is just out of view on the left.

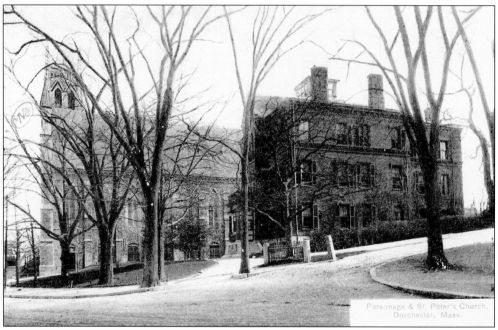

ST. PETER'S ROMAN CATHOLIC CHURCH. This card shows the church and the parsonage in a view to the west. The number of images of the church demonstrates again that monumental buildings were popular subjects of photography, as well as a source of pride for Dorchester residents.

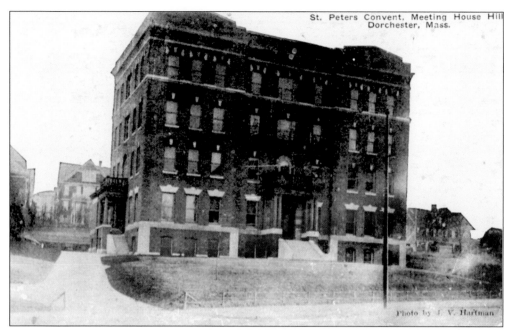

St. Peters Convent, Meeting House Hill
Dorchester, Mass.

Photo by J. V. Hartman

ST. PETER'S CONVENT. St. Peter's Convent, a four-story brick building, which sits on Bowdoin Street at the corner of Mount Ida Road, was finished in the autumn of 1906.

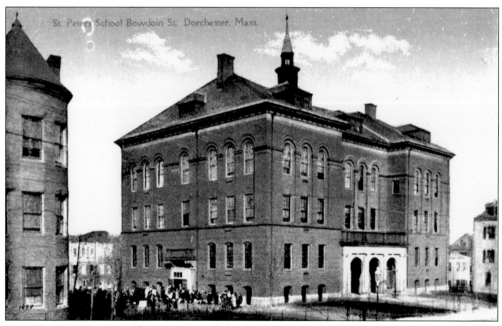

St. Peters School Bowdoin St. Dorchester, Mass.

THE PARISH SCHOOL. The erection of the Parish School, a three-story brick building, was finished in 1898.

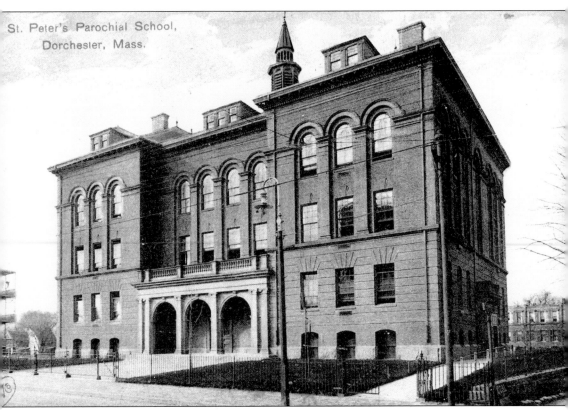

St. Peter's Parochial School,
Dorchester, Mass.

ST. PETER'S SCHOOL. Fr. Peter Ronan took on the task of developing a school to accommodate 1,000 children. This number was derived from the discovery that 7,000 baptisms had taken place during the previous 25 years. The school is entered through a triple-arched porch with pilasters in the Ionic order. When the building opened, it had 15 classrooms, an assembly hall, recreation areas, and administrative offices.

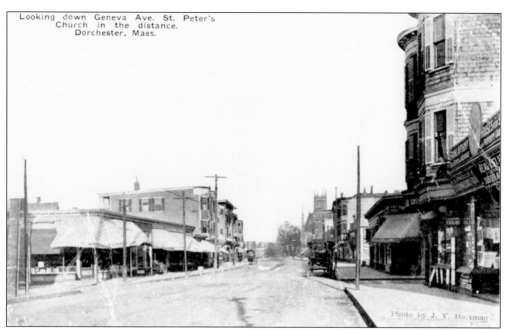

BOWDOIN STREET. The title of this card should be "Looking Down Bowdoin Street." Bowdoin Street derived its name from the Hon. James Bowdoin. The Bowdoin estate, also known as the Costello estate, was situated between what is now Bowdoin Street and Bowdoin Avenue.

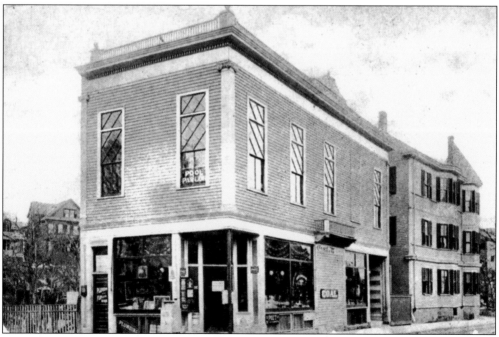

NO. 251 BOWDOIN STREET. This view shows the F. E. Patten building at 251 Bowdoin Street. The building, although much altered, still stands at that location and houses the Smile Again used appliance company.

73

Consumptives Home, Quincy St.,
Dorchester, Mass.

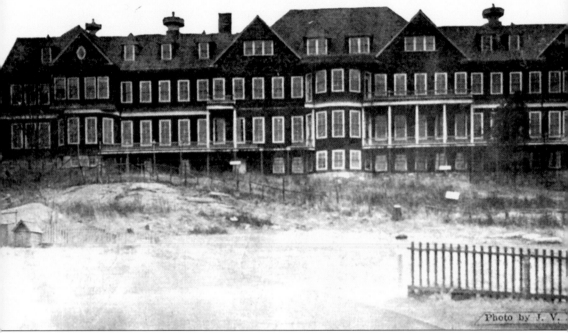

Photo by J. V.

CONSUMPTIVES HOME. Under Catholic control, like St. Mary's Infant Asylum and Lying-In Hospital on Cushing Avenue, the Free Home for Consumptives accepted patients of all religious faiths. The building was located on the north side of Quincy Street, not far from Meeting House Hill.

Six

GLOVER'S CORNER, SAVIN HILL, COLUMBIA, AND EDWARD EVERETT SQUARE

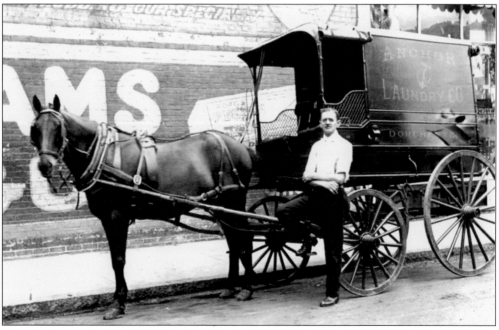

ANCHOR LAUNDRY. The 1918 Boston directory lists the Anchor Laundry at 95 Freeport Street. The intersection of Freeport Street and Dorchester Avenue has long been known as Glover's Corner and has been a major commercial area for Dorchester.

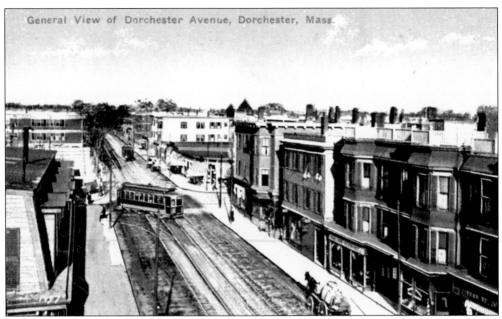

DORCHESTER AVENUE. The date of this scene is apparently 1913, as that was the only year that both Weiss and O'Keefe shops were near each other on Dorchester Avenue. The cross street is Savin Hill Avenue.

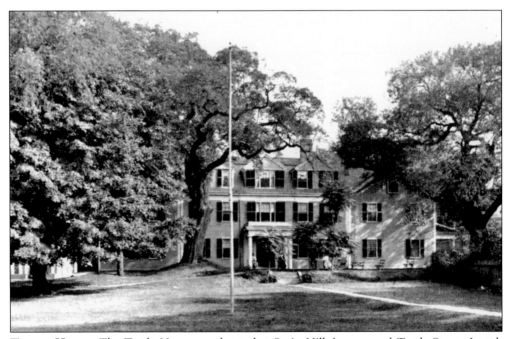

TUTTLE HOUSE. The Tuttle House was located at Savin Hill Avenue and Tuttle Street. Joseph Tuttle came into possession of the old Wiswell (or Wiswall) estate in 1822, and he made it into a seaside or country hotel, the first of its kind in the vicinity of Boston.

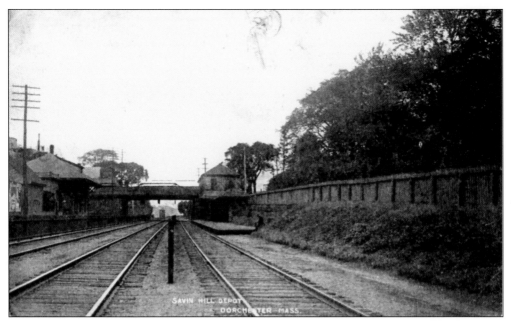

Savin Hill Depot. This card, published by the Putnam Art Company and postmarked August 1909, shows the Savin Hill Depot. Originally, Savin Hill was a stop on the Old Colony Railroad line and was later part of the subway system.

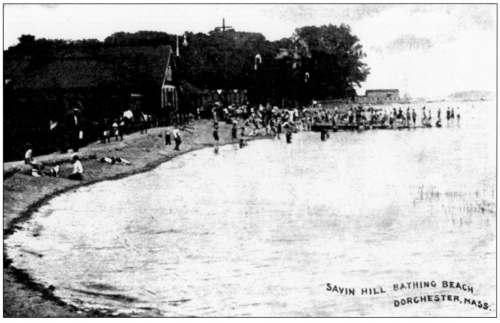

Savin Hill Beach. Dorchester has a long coastline with popular beaches like this one at Savin Hill.

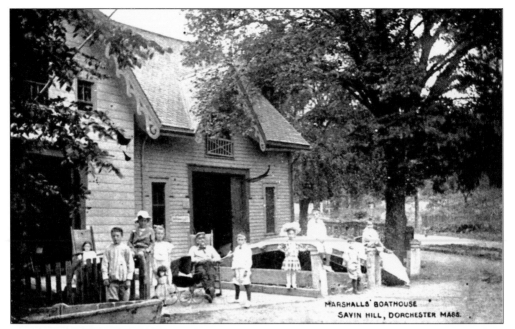

MARSHALL'S BOATHOUSE. The shoreline has always had a number of boathouses and marinas along with wharves and mills.

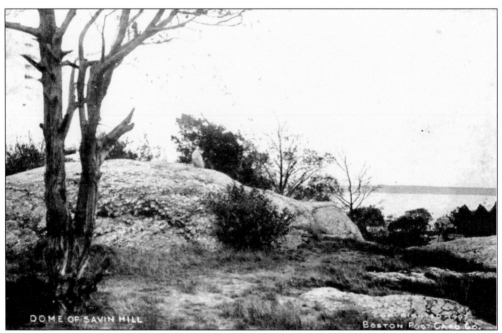

THE DOME OF SAVIN HILL. The dome of Savin Hill was a popular spot into the 20th century, and it showed the rural nature of Dorchester.

NORTH PATH

COPYRIGHTED 1907
BOSTON POST CARD CO

SAVIN HILL. Postmarked August 5, 1923, this card also attempts to emphasize the city's bucolic setting. Though Dorchester was fast becoming an urban area, photographers were still able to find a few settings that showed Dorchester as it had appeared in the past.

ST. WILLIAM'S CHURCH, DORCHESTER, MASS. 7321

ST. WILLIAM'S CHURCH. St. William's became a parish when it was set off from St. Peter's in 1909. St. William's consisted of territory south of St. Margaret's nearly to Glover's Corner, including the Savin Hill district. The Rev. James J. Baxter was the first pastor, and he bought the Worthington estate at the corner of Dorchester Avenue and Belfort Street for the construction of a church. The old mansion was adapted as a rectory.

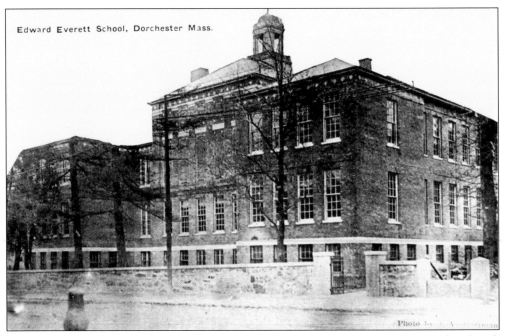

EDWARD EVERETT SCHOOL. The wooden Everett School on Sumner Street was replaced with this more commodious school on Pleasant Street in 1876.

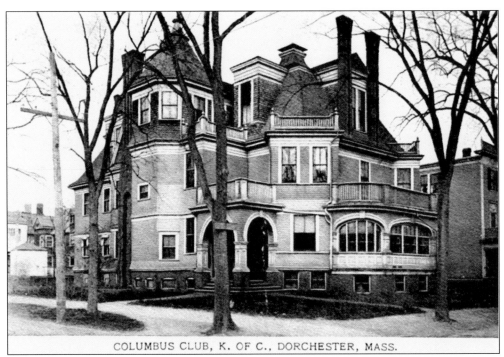

OLD DORCHESTER CLUB. Originally the Old Dorchester Club, this building was later known as the Columbus Club of the Knights of Columbus, and it is now used as Christ the Rock Church. It is a massive, late Queen Ann–style structure designed by architect W. H. Besarick and completed in 1892.

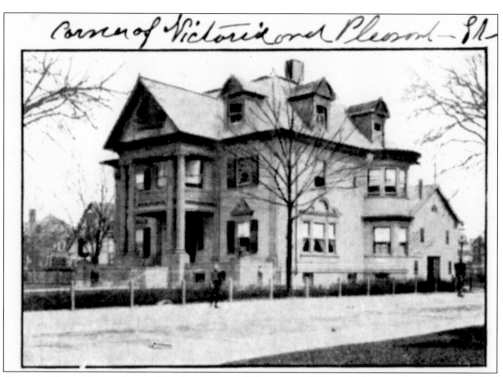

BURNAP FREE HOME. Located at the corner of Pleasant and Victoria Streets, this is the so-called Filene's mansion. It is a Colonial Revival mansion with central portico and a recessed porch in pediment. It is now divided into residential condominiums.

CHANNING CHURCH. Organized in 1900, the Channing Church was located on East Cottage Street, near Dorchester Avenue. In the late 20th century it was used by the Little House social services agency.

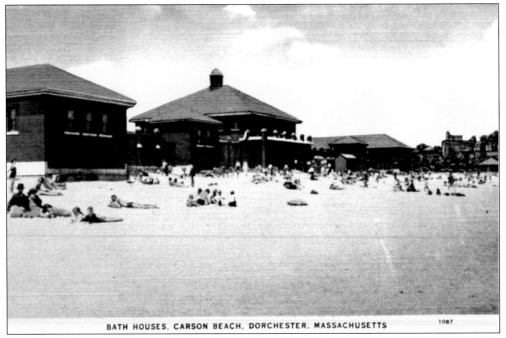

BATH HOUSES. CARSON BEACH. DORCHESTER. MASSACHUSETTS 1087

CARSON BEACH. Interestingly, the American Art Post Card Company seemed to think that Carson Beach is part of Dorchester, although it is really part of South Boston. Dorchester residents, however, have used the beach as if it were their own.

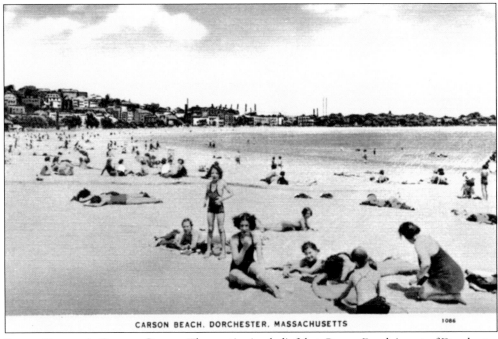

CARSON BEACH. DORCHESTER. MASSACHUSETTS 1086

SOUTH BOSTON'S CARSON BEACH. The continuing belief that Carson Beach is part of Dorchester has no basis in fact. The beach is really part of South Boston.

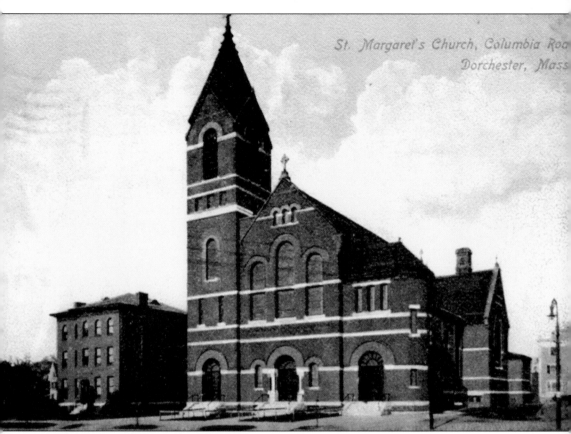

ST. MARGARET'S ROMAN CATHOLIC CHURCH. Built in 1904 from the Romanesque design of architects Keeley and Houghton, St. Margaret's Church is located at the intersection of Dorchester Avenue and Columbia Road, on the grounds of the former Andrews estate.

ST. MARGARET'S ROMAN CATHOLIC CHURCH, 1915. This card, which was published by the German Novelty Company of Boston, was postmarked November 4, 1915. In 1893, St. Margaret's Church was set off as the first large offshoot from St. Peter's. St. Margaret's was composed of the northeastern limits of St. Peter's Parish, including the portions lying south of Washington Village, South Boston, and along the line of Dorchester Bay nearly to Savin Hill.

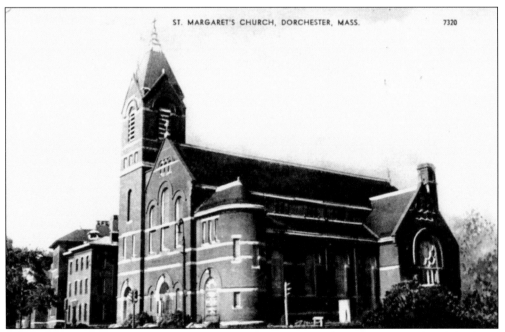

BLESSED MOTHER TERESA OF CALCUTTA PARISH. Today the St. Margaret's Church building serves a combined parish. St. Margaret's has combined with St. William's to form the Blessed Mother Teresa of Calcutta Parish.

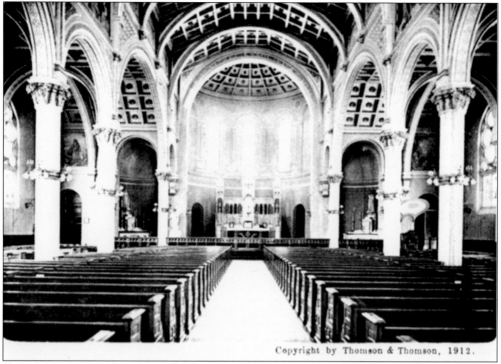

Copyright by Thomson & Thomson, 1912.

St. Margaret's Roman Catholic Church, 1912. This card from 1912, along with the others of St. Margaret's Church, shows the popularity of this church as a subject for photographers.

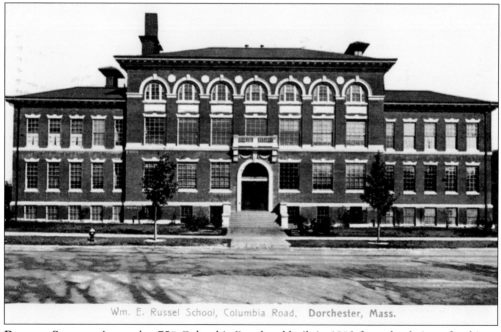

Wm. E. Russel School, Columbia Road, Dorchester, Mass.

Russell School. Located at 750 Columbia Road and built in 1903 from the design of architect James Mulcahy, this school was named for William E. Russell, a governor of Massachusetts.

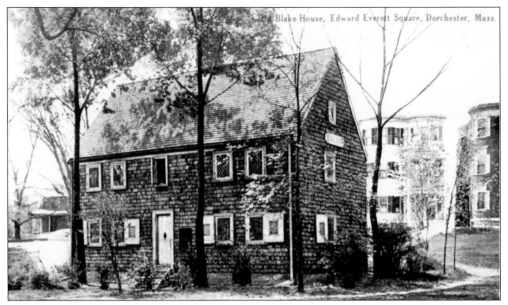

JAMES BLAKE HOUSE. Boston's oldest house, the James Blake House, built *c.* 1650, sits on Dorchester's Columbia Road, about 400 yards from its original location on West Cottage Street, near what is now Massachusetts Avenue. The house is thought to be one of very few surviving examples of English West Country framing in the United States. The house's original occupants were the newly married James Blake and Elizabeth Clap, who emigrated from England with their families in the 1630s.

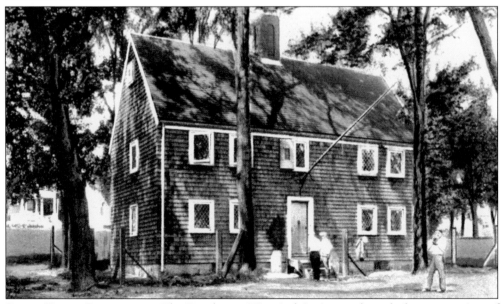

BLAKE HOUSE RENOVATION. The Dorchester Historical Society undertook the preservation of the Blake House as its first major project. The society convinced the city to grant them the house and the right to move it to Richardson Park at the society's own expense. By January 1896, the house had been relocated to its new site by a local building mover for $295. This seems to be the first recorded instance of a historic private residence being moved from its original location in order to rescue it from demolition.

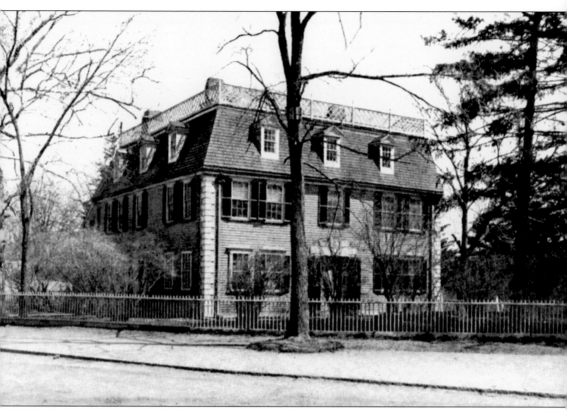

EDWARD EVERETT HOUSE. This house was built *c.* 1760–1770 by Loyalist colonel Robert Oliver. Rev. Oliver Everett bought the house, and Edward Everett was born there in 1794. Edward Everett, a famous orator, was the other speaker on the program when Lincoln presented his address at Gettysburg.

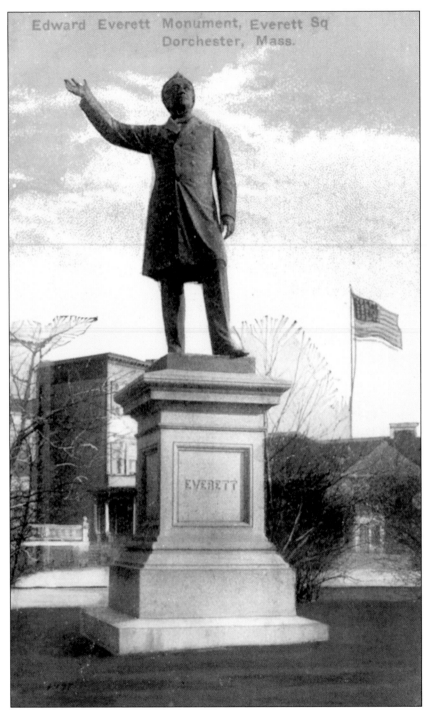

Edward Everett Monument, Everett Sq
Dorchester, Mass.

EDWARD EVERETT MONUMENT. Designed by William Wetmore Story of Salem in 1866, this statue was cast in Munich and set up in the Boston Public Garden as a gift to the city from the citizens of Boston on November 18, 1867. It was moved from the public garden in 1910, and in the following year it was taken to Dorchester and set up in the traffic circle at Edward Everett Square.

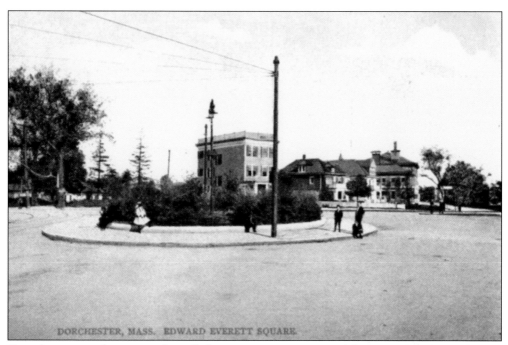

FIVE CORNERS. The square, also called Five Corners, was named for Edward Everett, a famous orator, president of Harvard, ambassador, and secretary of state, who was born in his family home at this intersection.

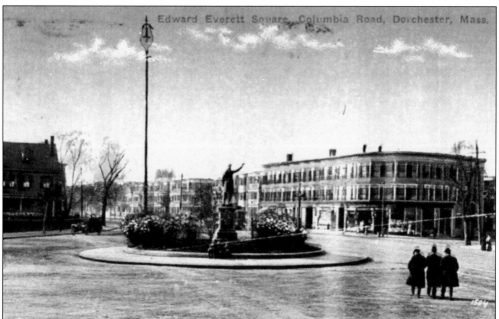

EDWARD EVERETT SQUARE. The Edward Everett monument was moved from the Boston Public Garden in 1910, and in the following year it was taken to Dorchester and set up in the traffic circle at Edward Everett Square. Toppled by motorists, it was removed on February 28, 1931, and was stored in the woodyard in Franklin Park. It was later rescued and placed in Richardson Park, near Edward Everett Square.

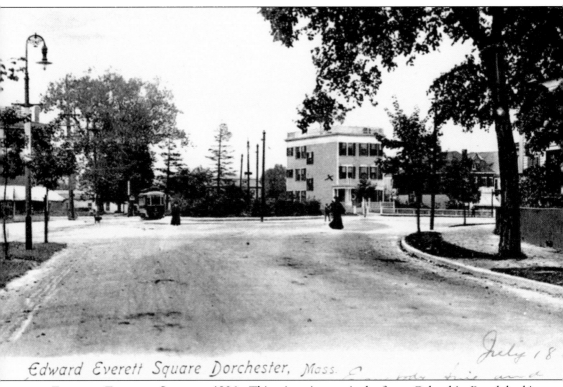

Edward Everett Square Dorchester, Mass.

EDWARD EVERETT SQUARE, 1906. This view is seemingly from Columbia Road looking northeast toward the traffic circle at Edward Everett Square. Postmarked in 1906, this card shows the circle before the Edward Everett statue was placed in the rotary.

Seven

DORCHESTER NORTH CEMETERY, JONES HILL, AND UPHAM'S CORNER

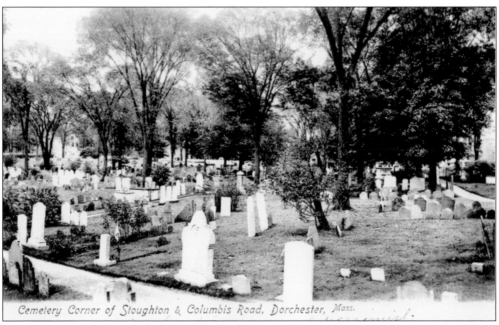

Cemetery Corner of Stoughton & Columbis Road, Dorchester, Mass.

OLD NORTH BURIAL GROUND. The Dorchester North Cemetery is the earliest cemetery in Suffolk County. Located at the corner of Stoughton Street and Columbia Road, its first gravestone was that of Barnard Capen, who died in 1638.

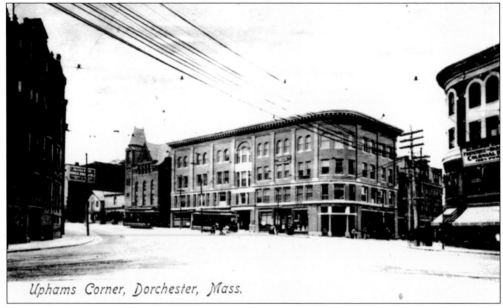

Uphams Corner, Dorchester, Mass.

UPHAM'S CORNER. Published by the Metropolitan News Company, this view shows Upham's Corner from the intersection of Columbia, Dudley, and Stoughton. The Dorchester apartment building at the left has been replaced by smaller buildings, including the Fleet Bank. Winthrop Hall is in the middle, and the Masonic Apartments are on the right.

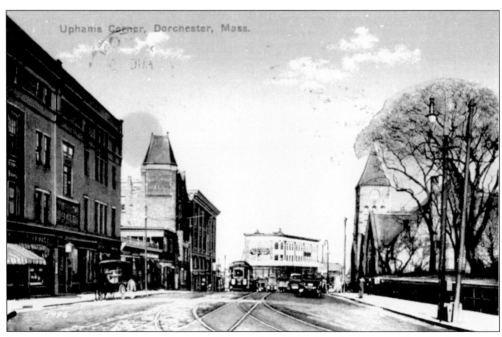

Uphams Corner, Dorchester, Mass.

SOUTHERN VIEW OF UPHAM'S CORNER. This card, published by the German Novelty Company, shows Upham's Corner from the south. Winthrop Hall is the middle building on the left. The S. B. Pierce Building is in the center, and the Baker Memorial Church is on the right.

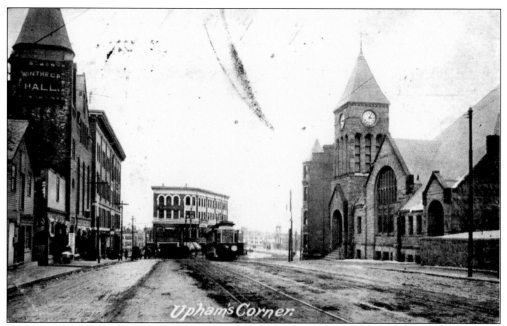

UPHAM'S CORNER. Upham's Corner is named for Amos Upham, who kept a general store at the corner of Columbia Road (at the time named Boston Street) and Dudley and Stoughton Streets. The site is now occupied by the Upham Building, known also as Masonic Hall.

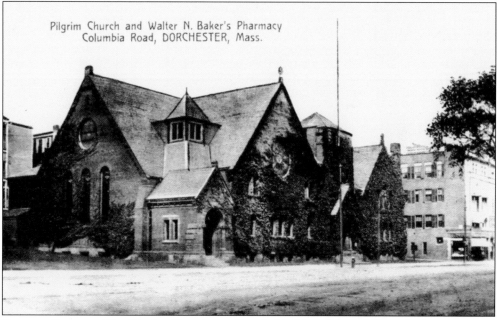

PILGRIM CHURCH. The Pilgrim Church was founded in November 1862, in the home of Rev. Edmund Squire, under the name of the Church of Jesus Christ. Its first building was constructed on Cottage Street in 1862, and this building was moved to Upham's Corner in 1878. The members adopted the name of the Pilgrim Congregational Church in November 1877, and in 1888 they began the construction of a new building on Columbia Road that was designed by Stephen Earle in the Romanesque Revival style. The building was completed in 1892.

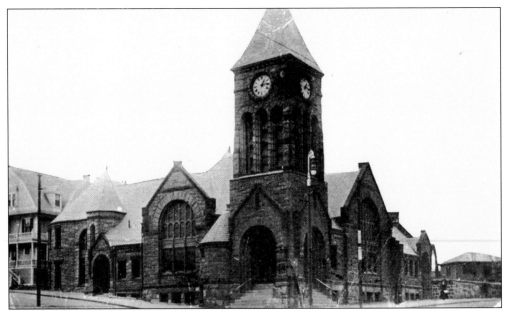

BAKER MEMORIAL CHURCH. The Baker Memorial Methodist Episcopal Church was located at the corner of Columbia Road and Cushing Avenue. Sarah Baker, a member of the First Methodist Episcopal Church near Lower Mills until her death in 1866, left an investment in her will to build a new Methodist church within three-quarters of a mile from her Savin Hill home. The money became available in 1886, at which time no church existed within the required limit. In 1899, the Mount Pleasant Methodist Episcopal Church in Roxbury disbanded, and contributed the proceeds from the sale of its property to the Baker estate. The church was reorganized at Upham's Corner, and its first meetings were held in Winthrop Hall, opposite the site of the proposed church. The site chosen was found to be 19 feet outside the required limit, and special permission was obtained from the court to use the funds from the Baker bequest.

ST. KEVIN'S CHURCH. St. Kevin's Parish was established in 1945 in Upham's Corner in a former telephone company building.

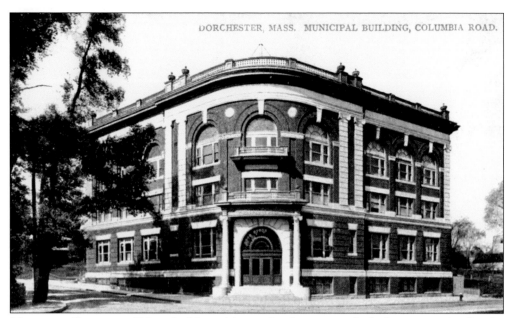

MUNICIPAL BUILDING. Although this card is not dated or postmarked, the message implies the date. "What do you think of the disaster—The *Titanic*—Did you ever read of any like it? Really I could not sleep after I read it, but I had to leave the papers alone."

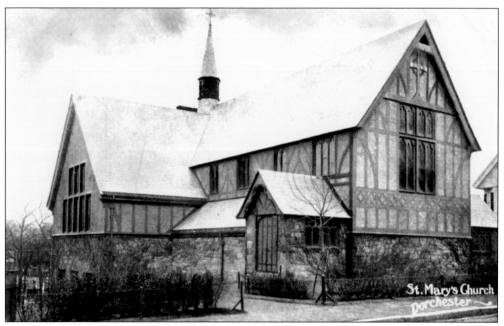

St. Mary's Church
Dorchester

ST. MARY'S EPISCOPAL CHURCH. St. Mary's Church, designed by Henry Vaughan in Jacobethan Revival style and built in 1888, is a prototype of modern Gothic. St. Mary's was one of Vaughan's earliest American commissions and his only known example of a building in the city of Boston. The church contains an important collection of stained-glass windows and displays extraordinary exposed timbers on the ceiling.

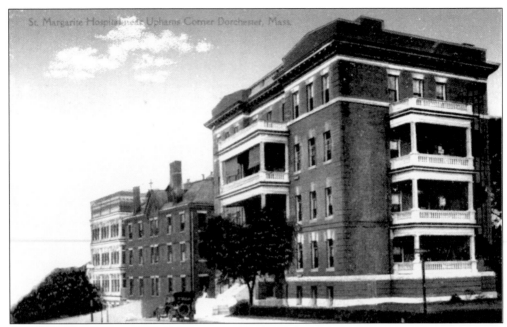

St. Margaret's Hospital. The maternity department of the St. Mary's Infant Asylum had its origin in Carney Hospital, in a small ward known as St. Ann's Ward. The ward's move to St. Mary's created efficiencies since the St. Mary's staff could care for the newly born as well. In 1910, a new maternity hospital, later called St. Margaret's, was constructed. This was an adjunct to the infant asylum and was to be operated by the Daughters of Charity of St. Vincent de Paul.

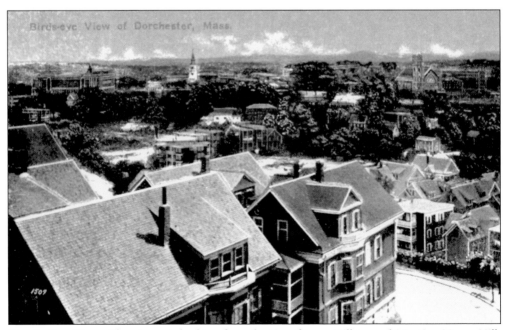

Bird's-Eye View. The viewer is looking from the top of Jones Hill toward Meeting House Hill. It is possible to see the Mather School on the left, the spire of the First Church in the middle, and St. Peter's Church on the right.

Eight

MOUNT BOWDOIN, GROVE HALL, AND FRANKLIN FIELD

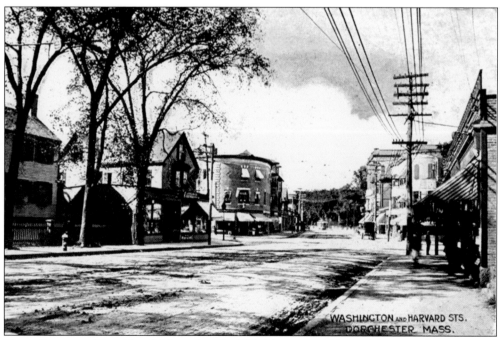

FOUR CORNERS. The title of this card reads, "Washington and Harvard Sts., Dorchester, Mass." It was not postmarked. The back of the card reads, "No. 1363. Pub. by Boston Post-Card Co., 12 Pearl St."

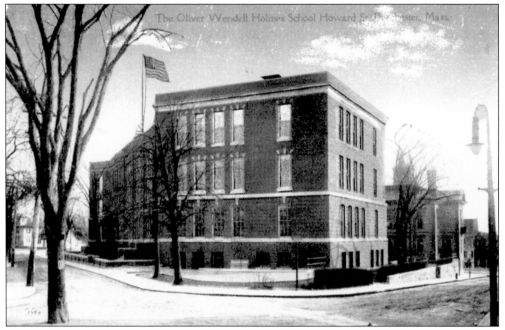

OLIVER WENDELL HOLMES SCHOOL. Located on School Street at Harvard Street, the Oliver Wendell Holmes School was named for the noted physician, novelist, poet, and essayist. Holmes wrote a poem with the title the "Dorchester Giant" to explain the origin of the puddingstone outcroppings that occurred in Dorchester and Roxbury.

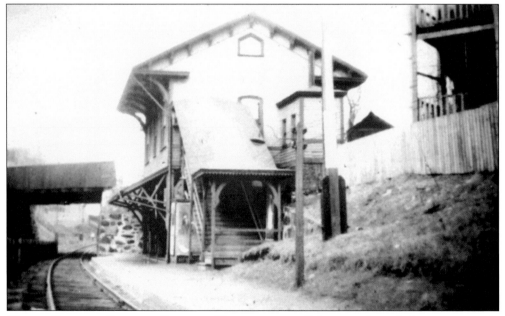

MOUNT BOWDOIN RAILROAD STATION. The commuter rail that runs through the more westerly side of Dorchester no longer stops at Mount Bowdoin, but for many years this station was busy with commuters going into Boston every weekday.

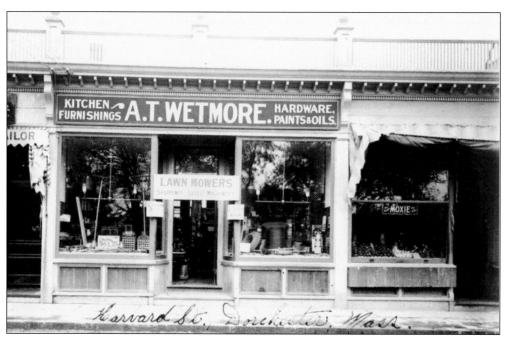

A. T. Wetmore Hardware. This picture of the Wetmore hardware store, which sold kitchen furnishings, hardware, paints, and oils, is another example of shops that existed in every neighborhood.

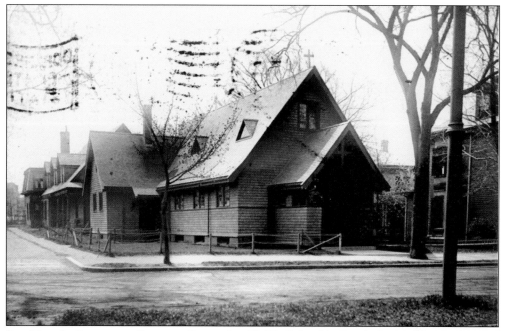

St. Mark's Episcopal Church. Located at 71–73 Columbia Road, St. Mark's was designed by Edmund O. Sylvester and is described as half-timbered. It was organized as a mission on March 7, 1898, and it became a parish on January 15, 1906.

WALES HOUSE. Nathaniel and Susan Wales came to Dorchester in 1635, and at the turn of the 20th century their descendants were still living here on their land. This house was located at the corner of Wales Street and Columbia Road.

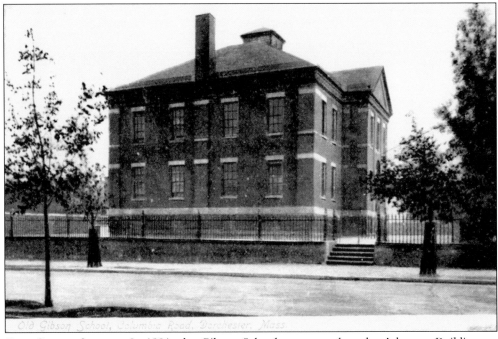

OLD GIBSON SCHOOL. In 1881, the Gibson School was moved to the Atherton Building on Columbia Road. When the Gibson moved to Ronald Street in 1895, this building became known as the Old Gibson School.

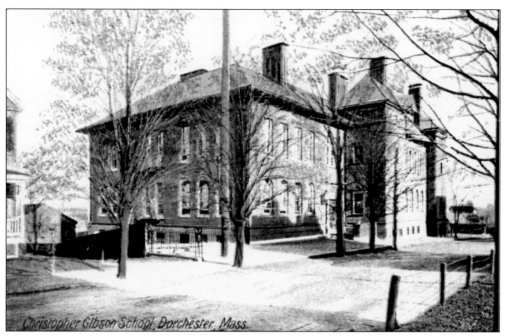

GIBSON SCHOOL. This Gibson School was located at 16 Ronald Street. Originally it was located on Bowdoin Avenue, which became Ronald Street. The school was built in 1895 and demolished in 1975.

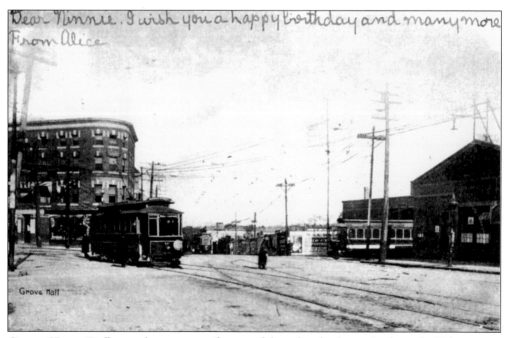

GROVE HALL. Trolley car barns were a feature of the urban landscape in the early 20th century. Grove Hall is a thriving commercial center, with Roxbury to the west and Dorchester to the east.

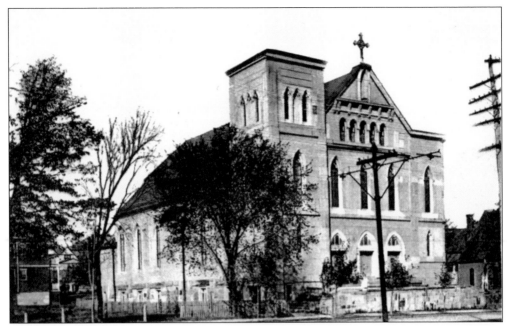

ST. HUGH'S ROMAN CATHOLIC CHURCH. The second pastor of St. John's, Fr. Patrick J. Supple, who served from 1908 to 1932, reconstructed the mission church, St. Hugh's, so extensively that it was rededicated by the cardinal on November 16, 1913. Although St. Hugh's sits on the west side of Blue Hill Avenue, which is in Roxbury, so many Dorchester parishioners attended the parish that the church was believed to be a Dorchester church.

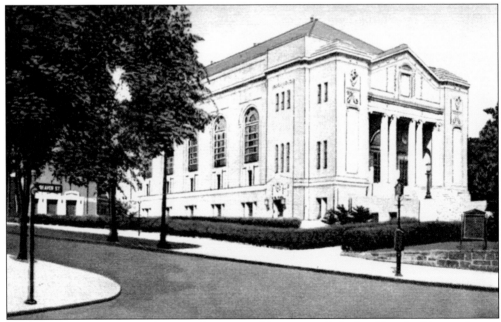

CONGREGATION MISHKAN TEFILA. Like St. Hugh's Roman Catholic Church, this temple was considered a Dorchester institution although it was located in Roxbury. It was the oldest conservative synagogue in Massachusetts, founded in 1895 by immigrants from East Prussia. The neoclassical building of Indiana limestone is now used by the United House of Prayer for All People.

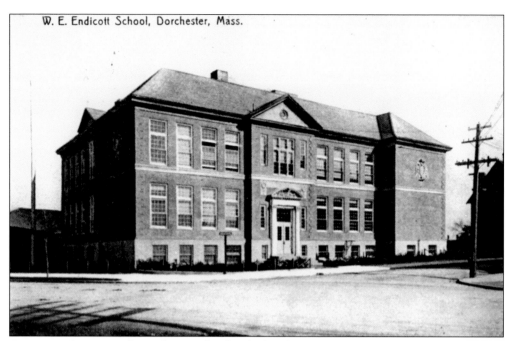

ENDICOTT SCHOOL. The Endicott School, which is located at 2 McLellan Street, was built in 1906 from the design of architect James E. McLaughlin. It was named for William Endicott, who served for 40 years in the Boston schools. After he served in the Civil War, Endicott started teaching at the Christopher Gibson School in Dorchester in 1866.

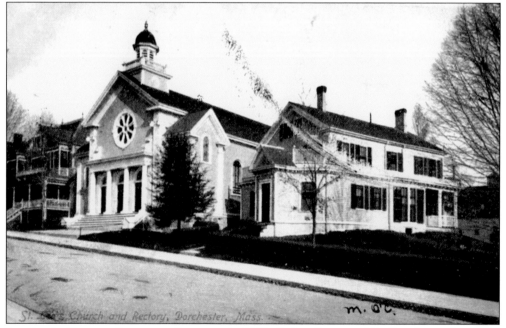

ST. LEO'S ROMAN CATHOLIC CHURCH. In 1901, Father Ronan of St. Peter's purchased the Bicknell estate on Esmond Street for the purpose of building a chapel to serve the southwestern reaches of St. Peter's Parish. In 1902, a portion of St. Peter's Parish was given for the formation of St. Leo's Parish at the western end of Dorchester, on Esmond Street beyond Washington Street.

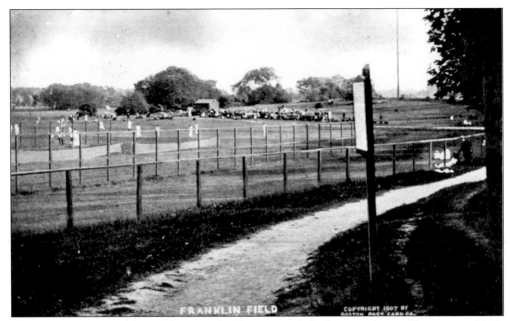

FRANKLIN FIELD. Franklin Field was used at first as a track for horse racing and later as an athletic field. In the early years of the 20th century, the horses of the Dorchester Gentlemen's Driving Club competed here.

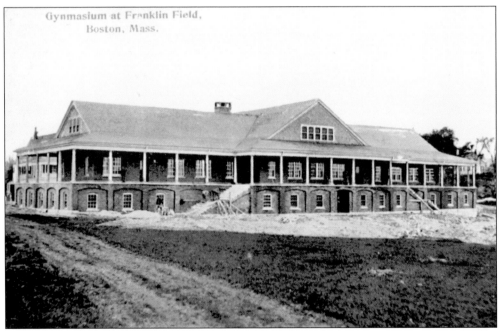

FRANKLIN FIELD GYMNASIUM. The gymnasium at Franklin Field served the community as an athletic facility, and the 77 acres of Franklin Field provided plenty of space for outdoor sports.

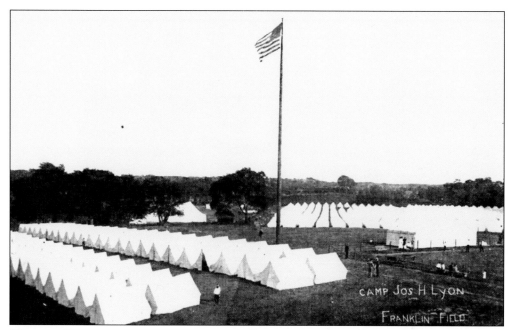

MILITARY EXERCISES AT FRANKLIN FIELD. Military exercises were held at Franklin Field in the temporary Camp Joseph H. Lyon.

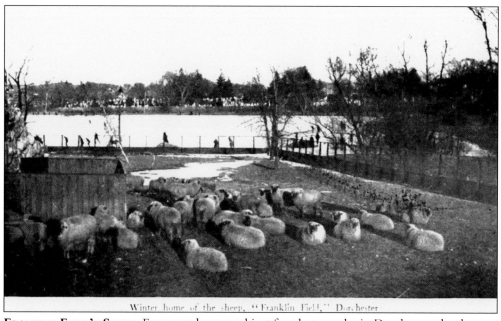

Winter home of the sheep, "Franklin Field," Dorchester

FRANKLIN FIELD'S SHEEP. Ever popular as a subject for photography in Dorchester, the sheep at Franklin Field helped to show Dorchester's bucolic character despite its urban setting.

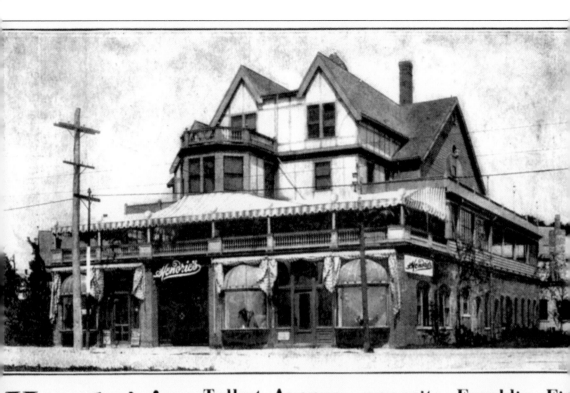

Hendrie's, Talbot Avenue, opposite Franklin Fie

WHERE HENDRIE'S FAMOUS FISH AND CHICKEN DINNERS ARE SER

HENDRIE'S. Joseph and Robert Hendrie began a catering business in the 1880s, and in 1892 they constructed a building on Howard Street. They later opened this restaurant on Talbot Avenue.

Nine

MATTAPAN

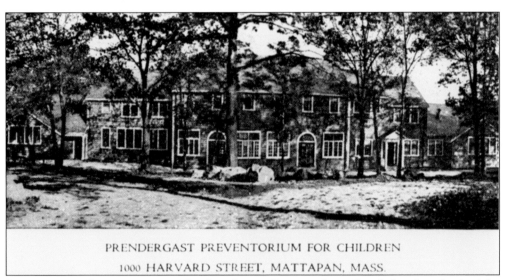

PRENDERGAST PREVENTORIUM FOR CHILDREN
1000 HARVARD STREET, MATTAPAN, MASS.

PRENDERGAST PREVENTORIUM. The Prendergast Preventorium, founded and maintained by Boston Brahmins, was a division of the Boston Tuberculosis Society. The preventorium was a place where the children of parents who had contracted consumption (tuberculosis) could be placed if the parents were institutionalized and there was no one to care for their children. Sometimes when one parent could not handle several children, one or more of the children would be sent to the preventorium until the home situation stabilized. When there was a possibility that a child had contracted the disease, the child might be sent to the preventorium so that others would not be exposed. After the preventorium was no longer in use, it was purchased by the entity that later was called the Combined Jewish Philanthropies. The Prendergast Preventorium building was used by the Ledgebrook Home, the orphanage of the Greater Boston Jewish Community, until the early 1950s.

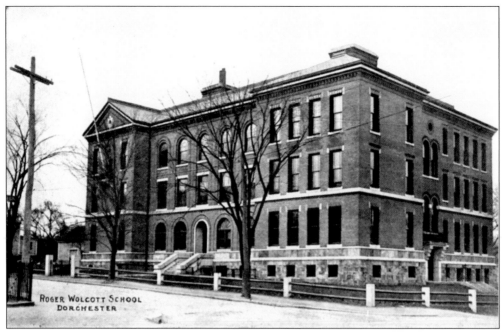

ROGER WOLCOTT SCHOOL. Located at Norfolk and Morton Streets, the Roger Wolcott School was a source of pride for the neighborhood.

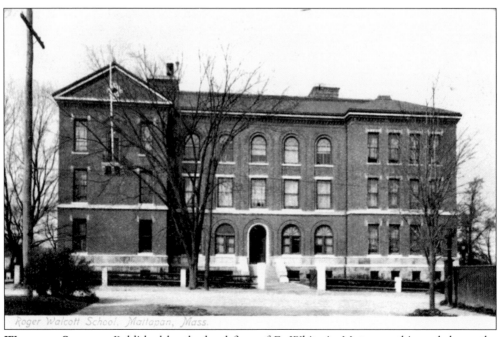

WOLCOTT SCHOOL. Published by the local firm of E. White in Mattapan, this card shows the Roger Walcott School, which was built in 1901.

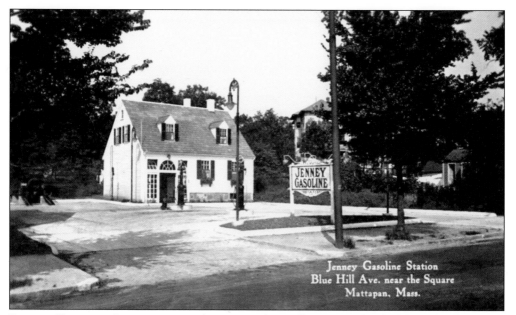

JENNEY GASOLINE STATION. Located at 1569 Blue Hill Avenue, this building is said to have been used as the first school in Mattapan. Construction is estimated as early as 1790. In the 20th century, the building was transformed into a Colonial Revival–style gas station.

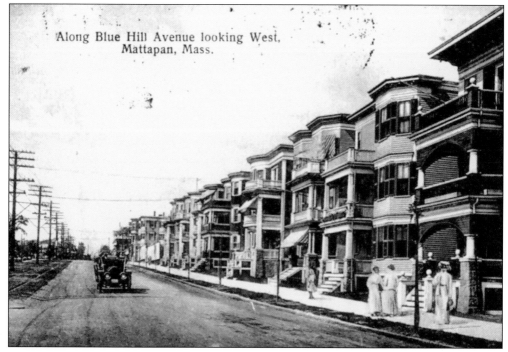

BLUE HILL AVENUE HOMES. Thomson and Thomson of Boston published this card showing a typical view along Blue Hill Avenue with a row of three-deckers.

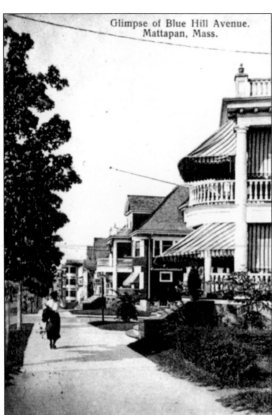

Glimpse of Blue Hill Avenue.
Mattapan, Mass.

BLUE HILL AVENUE, 1914. This glimpse of Blue Hill Avenue in Mattapan, which was published by Thomson and Thomson of Boston, shows the suburban nature of the town in 1914.

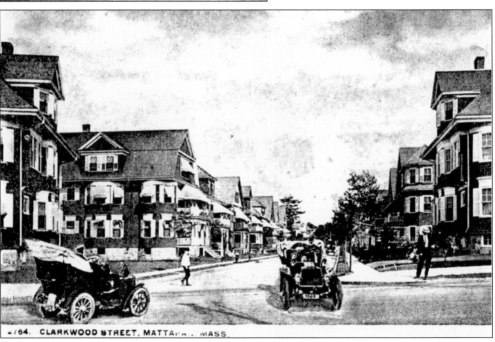

-/64. CLARKWOOD STREET, MATTAPAN, MASS.

CLARKWOOD STREET. A view of Clarkwood Street in Mattapan without street signs or telephone poles shows how the town appeared in the early 20th century.

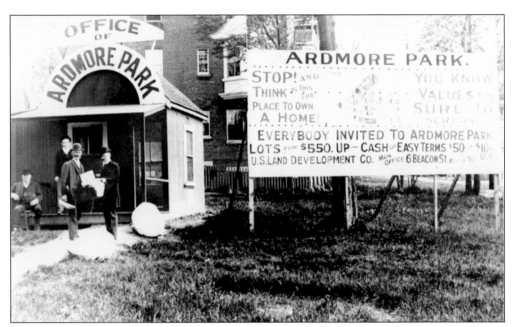

ARDMORE PARK. This real-photo card with a picture of the office of Ardmore Park, advertises a property development in Mattapan.

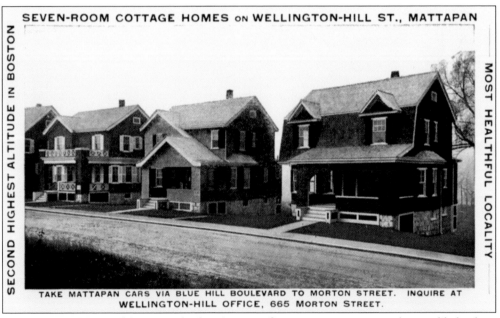

WELLINGTON HILL. This postcard advertisement for seven-room cottage homes likely dates from *c.* 1906. The Whiton Hall Entertainment Course booklet published in that year contains an advertisement for Wellington Hillside. On the verso of the card, it states that the cottages were being sold at $4,500, with a projected monthly mortgage payment of $26, including taxes and insurance.

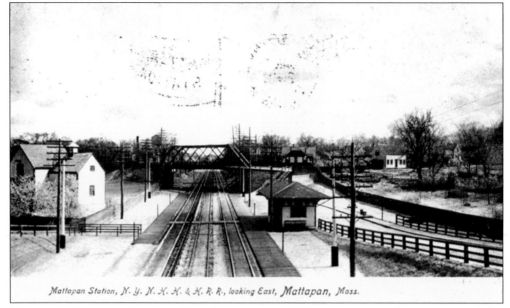

Mattapan Station, N. Y. N. H. & H. R. R., looking East, Mattapan, Mass.

MATTAPAN RAILROAD STATION. The photographer of this image was possibly standing on Blue Hill Avenue with Woodhaven Street at his back (although Woodhaven did not exist at the time). The bridge in the distance is on Norfolk Street, now Babson Street.

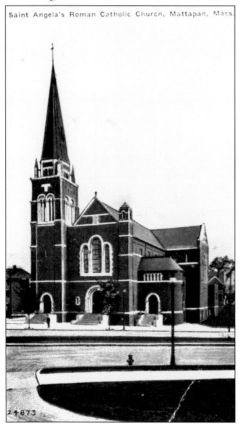

Saint Angela's Roman Catholic Church, Mattapan, Mass.

ST. ANGELA'S ROMAN CATHOLIC CHURCH. St. Angela's Parish was created on December 28, 1907, with territory taken in part from St. Gregory's and in part from the Church of the Most Precious Blood in Hyde Park. St. Angela's Church is a red brick church of the Roman style, located at 1548 Blue Hill Avenue in Mattapan. It was begun by Keeley and Houghton, and improved by Charles Maginnis in 1918.

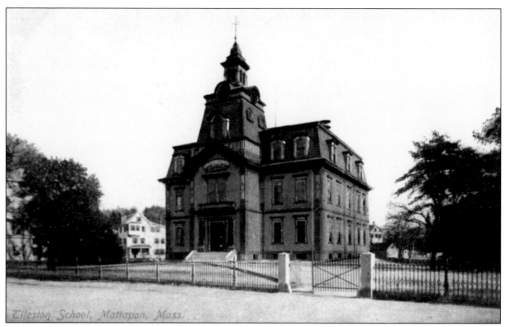

TILESTON SCHOOL. The Tileston School, erected in 1868 and located on Norfolk Street in Mattapan, was named for the Hon. Edmund P. Tileston, for many years the foremost paper manufacturer in Dorchester.

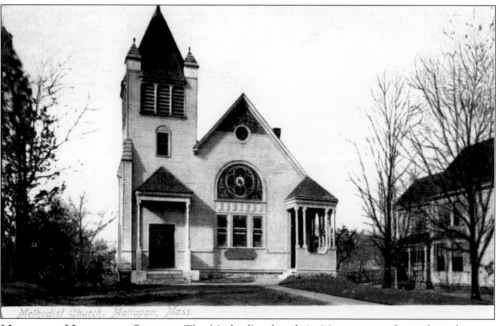

MATTAPAN METHODIST CHURCH. The Methodist church in Mattapan was located on the west side of Norfolk Street at approximately 743–745, across from the Tileston School and not far from the intersection of Fremont Street. The Mattapan Methodist Episcopal Church was formed after preaching services began in Mattapan as early as 1845. The services were moved from Oakland Hall to the Episcopal Chapel on Norfolk Street, and this edifice was dedicated as the Methodist Episcopal Church on March 11, 1875.

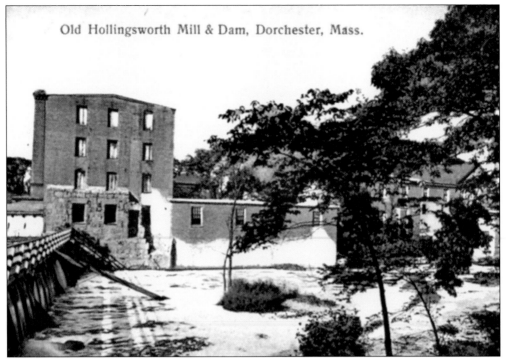

Old Hollingsworth Mill & Dam, Dorchester, Mass.

Hollingsworth Mill. Jeremiah Smith Boies built a paper mill in 1793 between the Lower and Upper Falls on the Dorchester side of the Neponset. It was here that Mark Hollingsworth went to work in 1798 after learning the trade of paper making in Delaware, and 1801 he joined with Edmund I. Tileston to buy the mill and establish the firm of Tileston and Hollingsworth.

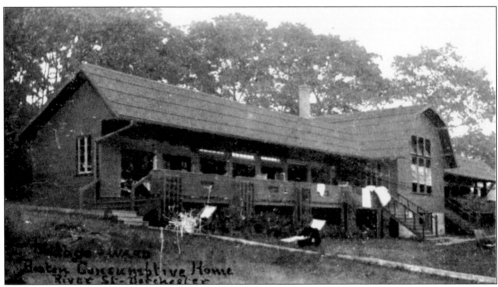

Boston Consumptives Home. In 1906, the Boston City Council created the Consumptives Hospital Department, and in the spring the trustees purchased the estate of Mary R. Conness for the construction of a hospital. The property consisted of 58 acres on River Street in Mattapan. This card shows the cottage ward, one of the outbuildings used by the day camp.

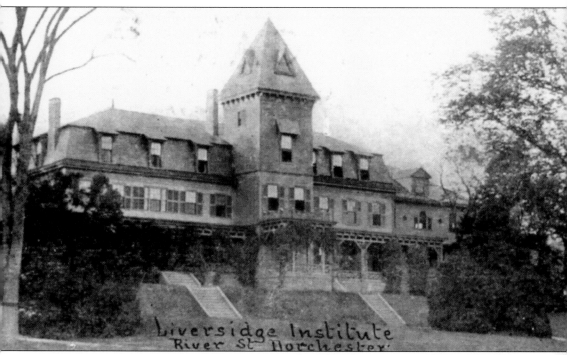

Liversidge Institute
River St. Dorchester

LIVERSIDGE INSTITUTE. The Liversidge fortune was made in the manufacture of starch. The Liversidge Institute of Industry was for boys only, and they had to be natives of England or New England. Located on River Street in the Liversidge farm, about halfway between Lower Mills and Mattapan, the Liversidge Institute received and trained poor and neglected boys between the ages of 7 and 14. The founder of this charity was born in England, but he spent nearly the whole of his life in Dorchester.

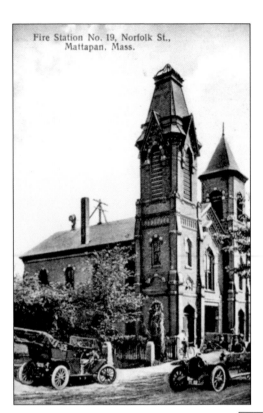

Fire Station No. 19, Norfolk St., Mattapan, Mass.

FIRE STATION NO. 19, NORFOLK STREET. Fire Station No. 19 was located at 128 Norfolk Street, not far from Mattapan Square.

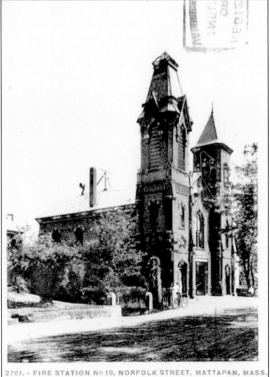

NORFOLK STREET FIRE STATION. Institutional architecture was a perennial favorite of photographers, and it is interesting when we have multiple images of the same scene to compare.

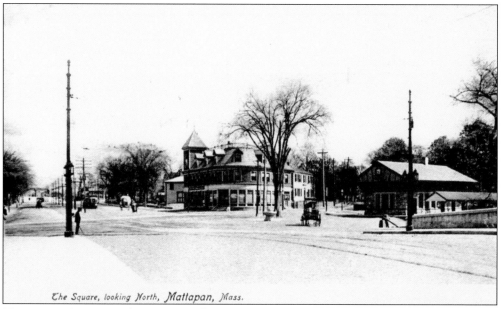

The Square, looking North, *Mattapan, Mass.*

MATTAPAN SQUARE. Like Lower Mills, Mattapan Square was a major commercial center for both Dorchester and Milton. This card shows the intersection in a view looking north from the bridge over the Neponset.

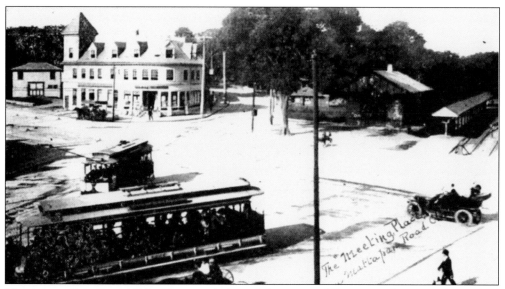

The "Meeting Place," Mattapan Road.

MATTAPAN SQUARE, 1913. The popularity of the automobile spawned groups devoted to automobile transportation. The Mattapan Road Club met here in Mattapan Square, as shown in this card postmarked in 1913.

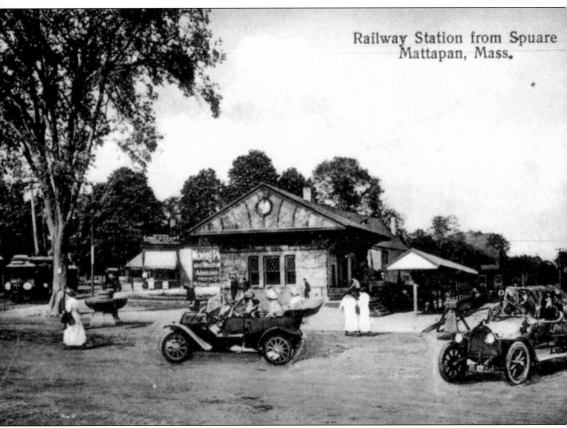

Railway Station from Spuare
Mattapan, Mass.

MATTAPAN RAILROAD STATION. The Mattapan Station building opened in 1856 and closed in the late 1920s, after which it was sold and converted to commercial use. The steam railroad carried commuters from Mattapan and surrounding areas to the Old Colony Railroad's Boston terminal on Kneeland Street. In the 1950s the building housed a barbershop—the Terminal Barbershop. Papa Gino's restaurant operated there until the late 1980s. Nick's Pizza was the tenant after that, until 2003.

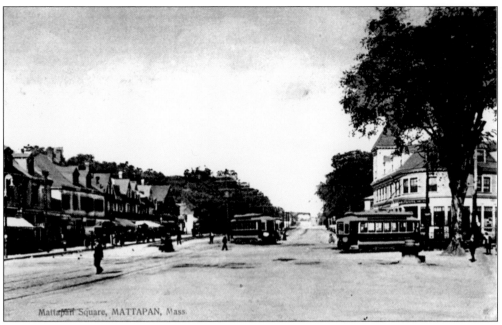

LOOKING NORTH FROM MATTAPAN SQUARE. This northward view of Mattapan Square shows the ever-present trolley cars and the tightly spaced shops lining the square.

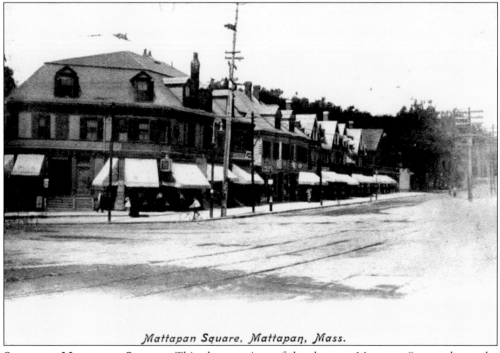

SHOPS AT MATTAPAN SQUARE. This closeup view of the shops at Mattapan Square shows the mix of first-floor storefronts with residential apartments above.

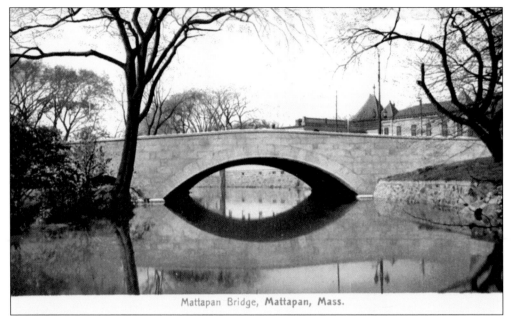

Mattapan Bridge, Mattapan, Mass.

MATTAPAN BRIDGE. The Blue Hills Parkway and the Mattapan Bridge were constructed in 1901, and they were meant to provide a route for automobile excursions, as well as for commercial traffic.

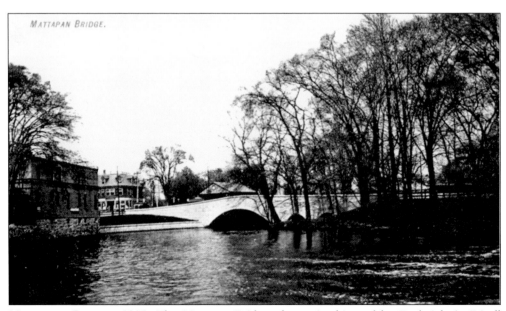

MATTAPAN BRIDGE.

MATTAPAN BRIDGE, 1905. The Mattapan Bridge, shown in this card by Frederick A. Frizell published in 1905, was designed by Wheelright and Haven.

You are invited

to attend

MY

5th. Birthday Party

December 10, 1908

2 to 4 P.M.

To be given in the lecture room, Mattapan Baptist
Church

MATTAPAN BAPTIST CHURCH. Said to have been on Blue Hill Avenue, the Mattapan Baptist Church is now located in Milton. This postcard from 1908 seems to be the only existing image of the earlier church building.

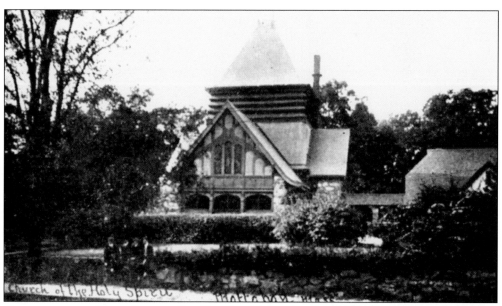

CHURCH OF THE HOLY SPIRIT. The Church of the Holy Spirit began as a mission of All Saints Church in the 1880s.

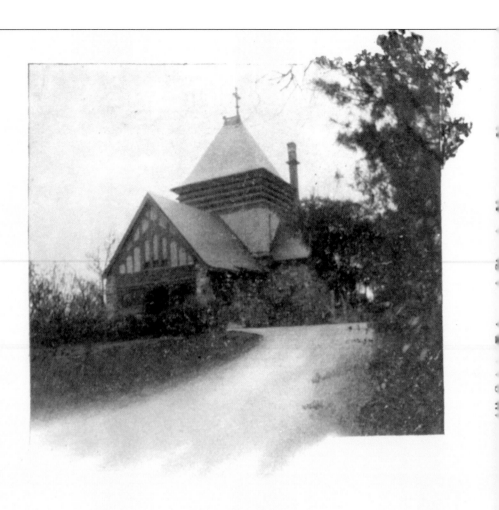

CREATION OF THE CHURCH. The church building, a stone Gothic Revival–style church, was given by Annie Lawrence Lamb in memory of her father Benjamin Rotch. It was designed by Arthur Rotch to emphasize the topography of the site by harmonizing the puddingstone of the church with that of the grounds.

Ten

GENERIC AND
AMUSING CARDS

I'M WAITING. This postcard with the title, "I'm waiting for your mail in Dorchester. Why don't you write?" is postmarked September 19, 1912.

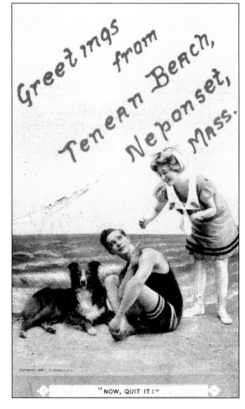

"NOW, QUIT IT!"

GREETINGS. This generic beach scene carries the title, "Greetings from Tenean Beach, Neponset, Mass."

COLD PROPOSITIONS. From the so-called Anglo Kids Series, this card could have been used for any neighborhood or town.

GREETINGS FROM MATTAPAN. The floral illustration and banner for the name Mattapan could just as easily have incorporated the name of any other town.

EVERYBODY IS DOING IT. This is another illustration that could have been used for anywhere in the country. Amusing captions such as, "Everybody is doing it in Dorchester and believe me I am one of them," seem to have been popular in the postcard industry.

SOMETIMES THE GIRLS. Meant to be amusing, this card, which was postmarked in 1912, could have been used for any town or neighborhood.

PRETTY GIRLS. This message pennant card could have been printed with any name, but the sentiment is always current, "There Are Lots of Pretty Girls in Mattapan But None Like You."

PICTURES. This generic card must be one of the very early references to snapshots.

Howling Creatures. Generic children's cards with amusing captions are always popular.

There's a Reason. This card, postmarked in 1915, is generic and could have been printed with the name of any town.